TEACH YOURSELF

Calligraphy

D0720522

PATRICIA LOVETT

NTC NTC Publishing Group

Long-renowned as *the* authoritative source for self-guided learning – with more than 30 million copies sold worldwide – the *Teach Yourself* series includes over 200 titles in the fields of languages, crafts, hobbies, sports, and other leisure activities.

This edition was first published in 1993 by NTC Publishing Group, 4255 West Trophy Avenue, Lincolnwood (Chicago), Illinois 60646 – 1975 U.S.A. Originally published by Hodder and Stoughton Ltd.
Copyright 1992 by Patricia Lovett

Library of Congress Catalog Card Number: 93–85093

Printed in England by Butler & Tanner Ltd, Frome and London

Contents

Thanks

...are due to my many students, colleagues and friends who have increased my knowledge of the craft and honed my ideas and techniques on teaching. I owe a great debt to my own teachers. Rosemary Sassoon not only made helpful suggestions for this book but also shaped my initial ideas of lettering and approach to the subject. These were refined by Anthony and Margaret Wood and Gerald Mynott at Reigate College of Art on a course which specialised in the traditional skills of the scribe and which has since, sadly, closed. I am also grateful to fellow associates of the Society of Scribes and Illuminators (now named the 'Advanced Training Scheme') and to our tutors, especially JohnWoodcock for his immense knowledge of lettering, and Gaynor Goffe for her unstinted energy, generosity of spirit, advice and time. Last, but certainly not least, thanks are due to my family, whose patience and forbearance whilst I have been scribbling – calligraphically or otherwise – has been sorely tested!

Introduction

Calligraphy means beautiful writing. Making beautiful letters is not just the prerogative of scribes with many years' experience. Adults and even children on a morning's course can write well-formed letters which delight the eye. Practice, though, will mean that good letters will be made more frequently and more consistently. And practice is what you want to make it. Family commitments may mean that your time is very limited, and progress may be in fits and starts. Your schedule may allow you to spend a certain amount of time each week, or even more often, developing your skills. Whatever time you have, do not allow your lettering to become a chore. Calligraphy is to be enjoyed and to give pleasure. You will not make beautiful letters if you are down or feeling under pressure. Save your practice until you are in a better frame of mind. Of course, it helps if you are able to leave your board and pens set up so that you do not need to spend time at the beginning of each session getting everything ready, but this is a luxury of space that few of us have.

This book has been written both for people who have had no experience in calligraphy before as well as those with some knowledge who want to improve their skills. It starts at a basic level, writing with two pencils tied together and simple pencil patterns leading on to letter families, and then progresses to writing with a piece of cardboard or balsa wood. Expensive materials are not necessary to start the craft. When you are sure you enjoy what you are doing you can invest in pens, inks and

paints, a sloping board and other equipment.

Large-size letters, taken from classic alphabets, with direction strokes clearly marked, enable beginners to make progress. Four additional alphabets are also included, as well as numerals, punctuation marks and flourishes. The alphabets are taken from hands used in historical times. Visit exhibitions and museums to see the originals if you can. Those starting out in the craft should take a leaf from the book of professional scribes and use any opportunity to see original pieces of calligraphy – modern as well as historical. Good quality reproductions in books or even on postcards are a reasonable substitute, although with limitations. To put the alphabets into perspective, a brief overview of the development of Western writing is included at the end of the book.

Calligraphy nowadays is not just about black letters on white paper. Modern scribes use a number of different materials and techniques to achieve a variety of effects in their work. Many of these techniques are considered in this book as well as the more traditional skills of using gold and vellum. Practical ideas for using calligraphy in a number of projects are also included.

Most people think of calligraphy as writing with a broad-edge nib, and in fact, most of the lettering in this book is about using a broad-edge nib – but not all. Beautiful letters can be made with many different implements (not just what are traditionally accepted as pens) sponge, brushes, piano felt, balsa wood, twigs and sticks, amongst others.

More than anything else, calligraphy is about enjoyment and pleasure. When you sit at a board, and feel the pen bite on to the paper, see, and even smell, the wet ink flowing from the nib, and you are pleased with the marks you are making, you can then appreciate what a privilege it must have been to be chosen as a scribe in medieval times, so that you could sit and do this all day! In these early stages enjoyment and experimentation are far more important than the dull repetition of practising one letter to attain the perfect letterform – and possibly losing all spontaneity along the way.

This book is about ideas, techniques and methods. Dip into it, or follow it through from section to section, but above all, take pleasure from what you are doing.

1·Starting Out

When you start calligraphy there is so much that can seem unusual and strange – using a variety of pens, writing at a slope, holding your hand at a slightly different angle to normal – all of which may create some tension and anxiety. It is important to try to keep relaxed and free from tension when writing.

Writing with two pencils

Because of the importance of keeping relaxed, starting to write with two pencils taped together is recommended. Pencils are easier to push around to make letterforms and there are no problems with pens, nibs and ink. Double pencils have an additional advantage of showing exactly where strokes start and finish and this can be an indication of some future problems in achieving good lettershapes.

Pencils can be held together with elastic bands, or with two pieces of masking tape. (Clear adhesive tapes tend to become rather sticky after a while.)

The hardness of pencils

Make sure that the pencils are of equal hardness, indicated by the B and H marking. HB is medium. H indicates pencils with a harder point and B those which are softer. Given the choice, it is better to use harder pencils; calligraphers often use 4H and even harder points. The harder the pencil, the longer it will keep its sharp

point. Softer points tend to smudge and make work messy.

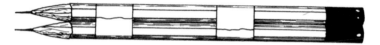

Right-handers should fix their pencils together so that the points are of equal length.

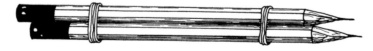

Left-handers should have the left-hand point lower than the right, as shown here.

If the two pencils feel rather bulky to hold, a slice can be taken away with a sharp knife from the *inner* edge of each one before they are taped together. You will need a knife to sharpen the points, as a pencil sharpener cannot be used when the pencils are attached to one another.

Scribbling
Start with a large piece of paper, possibly taken from a roll of lining paper from a do-it-yourself or a home decorating shop. Place this on a board which slopes at about 45°, (see pages 128 – 129 for setting up a board) and loosen up by making a scribble pattern all over the paper – *but* make sure that the two pencil points are held at the same angle whilst scribbling. This is not as easy as it seems; most people's inclination is to move their wrist and so change the angle.

Angle of lettershapes

This exercise is good practice for what is to come. One of the key points in writing with a broad-edge nib is that the *angle* at which the nib is held affects the shape of the letter. The nib is held at different angles for different alphabets.

Look at the letters below. They are the same letter, but the nib is held at three different angles. The white space, or *counter*, inside the letter is the shape to look for.

*The nib is at 45°
to the horizontal,*

here at 90°,

and here at 0°.

Pencil and pen patterns

When you feel comfortable about scribbling with your pencils held at the same angle you are ready to begin making patterns. Patterns help to get your hand and eye into the correct movements before you begin writing letters.

Draw horizontal lines about 5 cm apart across another piece of large paper. Measure out an angle of 30° using a protractor, or trace it from the angle shown below. Now match your pencil points up to this angle and, trying to keep the angle constant, make these patterns.

Mark lines 5 cm apart and measure an angle of 30°.

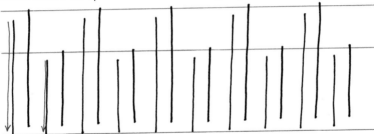

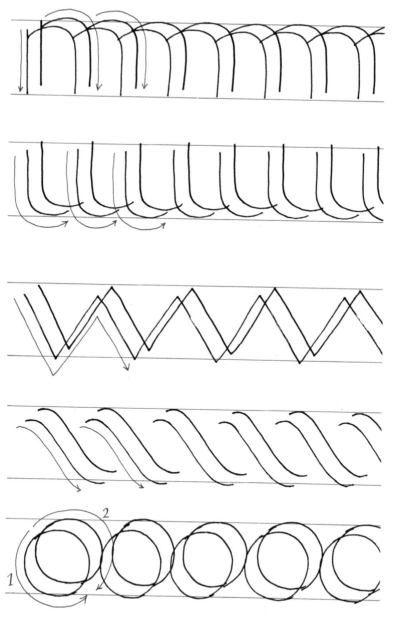

Double pencil patterns

It is not wasted time practising patterns like these. They can be used to decorate a greetings card or as a border for a larger piece of work. Making up more complicated patterns from the various elements is fun as well as good practice.

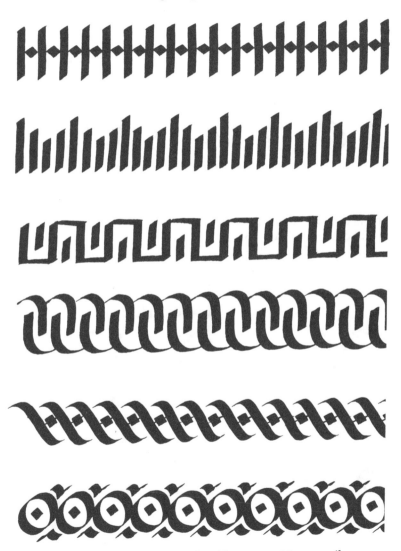

These patterns were made with a pen, not two pencils.

Letter height – x-height

The angle at which you hold your pen or pencils affects the lettershape. So too does the *height*. It helps to give the character to that alphabet. Look at these letters, all written with the same nib, they look different, thinner or thicker, because of their height.

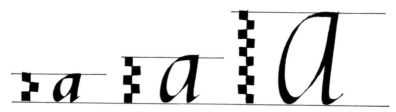

Letters written at 3 nib widths, at 5 nib widths and at 10 nib widths.

x-height

The height of the letters is called the *x-height,* because this is the height of the small letter **x**.

The parts of letters that go up, called *ascenders,* as on the letters **b d f h**, go above the line of the x-height; those parts that go down, called *descenders,* as on the letters **g j p q**, go below the line.

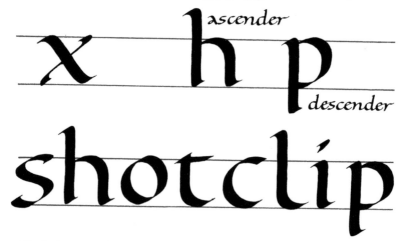

The body of the letters stays within the lines for x-height. Ascenders go above the lines and descenders below.

The x-height is measured in nib widths, or the width of whatever tool you are using for writing (the width between two pencil points if using double pencils).

Turn your double pencils so that they are horizontal and measure out the x-height like this:

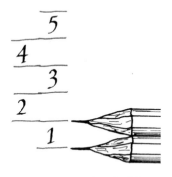

This x-height is five double pencil widths,

this x-height is five nib widths of a size 0 William Mitchell nib.

This is the way to measure x-height whenever you work. Remember to keep your pencils or pen nib horizontal to the line. The marks measuring the x-height just touch one another and should not overlap. The x-height will change according to the tool you are using. It will be larger for double pencils and smaller for pen nibs. For smaller pen nibs it will be smaller still!

Marking out x-height

On another piece of paper, measure the x-height of your double pencils at *four and a half* pencil-point widths down the page. Use every other set of these lines, to allow space for ascenders and descenders, otherwise they will clash.

You can draw out a series of steps with your pencils all the way down the page if you wish, but there are two quick ways of marking out x-height. One easy way is to mark off the x-height on to *a piece of scrap paper* and transfer that measurement on to your paper. Or you can use a set of *dividers*. These are similar to a set of compasses, but have a point at the end of both arms. Some quite cheap sets of compasses from high street stationers are supplied with spare leads and an extra point. It is then a simple matter to take out the pencil lead and insert the metal point. Open the

dividers so that each point touches the outer measurements of the x-height. Then 'walk' the dividers down the page; the pin pricks indicate the width of the x-height lines.

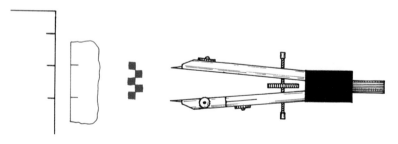

Mark out the x-height using the markings on a scrap of paper,　　　*or use dividers.*

Drawing lines

With a long ruler, a set square or a T-square draw horizontal parallel lines with a sharp pencil from the points measured. Keep your pencil at the same angle. If you change the angle the width of the lines will not be constant. Remember that this measurement indicates the height of the small letter **x**, ascenders and descenders go above and below these lines.

When you practise letters with the same nib size and x-height, you may prefer to draw guidelines in a very fine pointed pen on to a sheet of paper or card. The lines will show through a piece of layout paper or photocopying paper laid over the top, and will save you drawing lines on each sheet of paper.

Letter families

My first calligraphy teacher, Rosemary Sassoon, emphasised that in most alphabets the letters can be linked into families according to the strokes used to make them. This is easy to see with the family – **i l t u j**. The letters all start with a down stroke, with **l** and **t** that down stroke continues round, with **u** it continues round and joins another down stroke. Because of this, practising letters in letter families is easier than starting at letter **a** and working your way through the alphabet until you reach **z**.

The letters on the following pages are from Edward Johnston's *Foundational* or *Round Hand*. They are shown enlarged in the

chapter dealing with four alphabets on page 33.

Look carefully at the lettershapes in this alphabet. Although it is easy to move pencils around, a pen with a wide nib will spray ink if you try to push it. For this reason, most letters are formed with more than one stroke. The pen is pulled downwards or to the right. The following pages show the letters, written with double pencils, in their letter families. The stroke sequence and direction is shown by the coloured arrow and number.

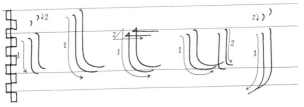

Letters which start with a down stroke.

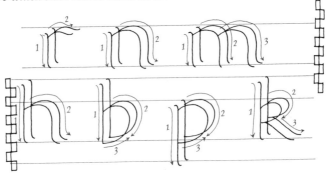

Letters which start with a down stroke and then arch.

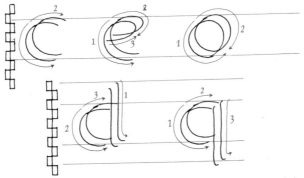

Letters based on a circle and which start with a stroke to the left.

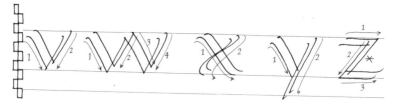

Diagonal letters.
** Note that the diagonal stroke on the letter z is made with the nib at a flatter angle than 30°. If the nib is left at 30° this stroke is very thin and weak. Turn the nib to about 10°– 15° to the horizontal for the diagonal stroke.*

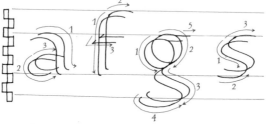

Those letters which do not fit these patterns.

Practise the letters in their letter families until you are sure of their form and the way in which they are constructed.

Practising words

A great deal of time can be spent practising the letters on their own, and when you begin to write words everything seems to fall apart. It is better to use the letters in words as soon as you are familiar with the lettershapes and their stroke sequence. Write the following words in double pencils:

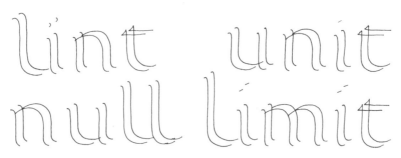

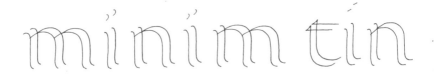

Notice that the words have been chosen so that the letters have straight sides. It is easier to see how to space the letters in words like these.

Spacing between letters

What you are trying to achieve in calligraphy is a visual balance and evenness. Spaces *within* the letters should be visually related to the spaces *between* the letters. However, there should always be a degree of flexibility, and not a slavish attention to exact and precise measurement.

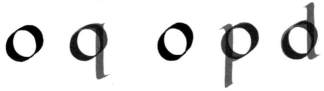

*The white space within the letter **n** is balanced by the white space between it and the letter **u**. The space within the letter **u** is balanced by the space between it and the last **n**.*

The round arch of the letter **n** is taken from the letter **o**. The circular shapes on letters such as **b d p q** are also formed from the letter **o**. The letters in one alphabet style relate to one another. So the same rule of spacing applies for all the letters in the alphabet. Letters which do not have straight sides are placed at related distances apart.

o q o p d

*You can see that round letters, such as **o e c** and the rounded parts of letters as **d p q**, will be spaced slightly closer together than letters with straight sides.*

Spacing between words

In a similar way, the spacing *between* words must relate to the letters. Leaving a 'finger space' between the words, as many of us were taught at school, will result in large gaps in the work, which will certainly not add to its balance, nor its readability.

The space between words is usually that of the letter **o** of that alphabet.

spaceobetweenowords

Round Hand

So a round, fat alphabet, such as Uncials, will have larger spaces between words than a narrower alphabet, such as Italic.

SPACEOBETWEENOWORDS

Uncial

spaceobetweenowords

Black Letter

spaceobetweenowords

Italic

*Leave the space of the letter **o** of the alphabet you are using between words.*

Space between lines

To avoid ascenders and descenders clashing, you need to leave sufficient space between the lines when writing out a piece of work. As a rough guide, the *minimum* amount of space to leave between the lines is just over the x-height, but this will not prevent some clashes, and you may need to write out the piece a

few times to respace the lines. A more formal piece will look best with a generous amount of space allowed. In this instance, leave three times the x-height. A piece written only in capital letters can be spaced with the lines much closer together. When you want to have the lines of writing closer spaced, write the piece out in rough to make sure that there are no descenders or ascenders clashing. Adjust the lines of writing and the spacing very slightly to avoid any unsightly collisions.

She flowed through life
All style and grace
Neatly inscribed
Into life's pages;
Deftly drafted lines
She followed precisely,
Her reactions flawless,
Inevitable YET

Leave at least the width of the x-height between lines.

Longing to let go

To skate across days

Given a free hand,

Unhampered by any design

To scribble

For a formal piece, allow at least three times the x-height between lines.

INTRICATE DOODLES
WHENEVER SHE PLEASED,
TO LIVE OUT THE FIRST
ROUGH DRAFT, ALWAYS,
SHE HAD LIVED YEARS
THAT LAY CRUMPLED
IN HEAPS BEHIND HER
SOON TO BE THROWN AWAY
ONCE AND FOR ALL.

Not so much space is needed between the lines if you write only in capital letters.

('Calligraphy' by Ted Walter. Reproduced by kind permission of the poet)

Now write out these phrases, trying to keep a balance in the spacing, leaving the width of the letter **o** between words and three times the x-height between lines.

time out

ten greenbottles

unlimited

alphabets

thirty tin cans

Using a pen

When you feel comfortable writing out letters and words in double pencils, start to write with a large pen. You can make yourself a pen from balsa wood or cardboard. Look at pages 26 – 28 to see how to do this. Or you can use a large size fountain or felt tip calligraphy pen, or a calligraphy dip pen. Turn to pages 87 – 93 for more information on this. Left-handers are advised to use a left oblique nib.

Start with writing letters in letter families, as before.

i l t u j

Letters which start with a downstroke.

r n m
h b p k

Letters which start with a downstroke and then arch.

c e o d q

Letters based on a circle which start with a stroke to the left.

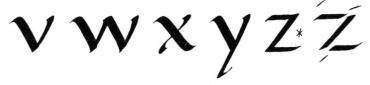

*Diagonal letters. *Turn the nib to 10° – 15° to the horizontal for this stroke.*

a f g s

Those letters which do not fit these patterns.

When the pen is working well, and you are familiar with the lettershape and movement, write out these words:

minim lint jut
hunt tint hit
mint hamper
over cow log

Now write out these phrases:

more haste, less speed

ten green botttles

calligraphy is fun

letters are lovely

Letter families for other alphabets

Once you are familiar with writing Round Hand letters, you may either want to pursue this one hand until you feel that it is perfect, or try others.

Italic

The x-height for Italic is slightly wider than that for Round Hand. You will need to measure out an x-height of 5 nib widths. Ascenders and descenders are longer too, often extending to eight or even nine nib widths in all. The nib is held at an angle of 45° and the letters are at a slight slope. At first it may help to draw out some parallel lines at an angle of 6° to the vertical, until you are used to the slope. Round Hand is based on a round letter **o**. Italic is based on an oval letter **o**. One of the characteristics of the hand is that the arches of letters such as **n m h p b** spring out from about halfway up the stem of the letter. This gives a little triangular white space. This is mirrored in a similar triangular white space on letters such as **a d g q**.

The arches spring out from about halfway up the main stem of the letter.

The triangular white space appears at the bottom of these letters.

Measure and draw out a series of horizontal lines at five pencil point widths down your paper. Remember that you will use every other one, to avoid ascenders and descenders clashing. Draw an angle of 45° at the top of your paper. Also draw parallel lines at 6° to the vertical across your paper until you are used to the slope. Practise the letters in their families.

The letter families for Italic are on the next page:

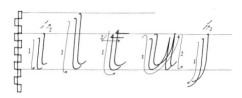

Letters which start with a down stroke.

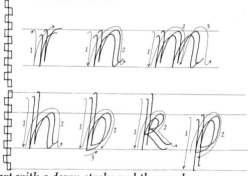

Letters which start with a down stroke and then arch.

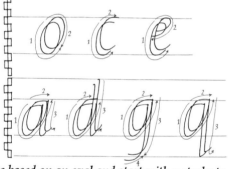

Letters which are based on an oval and start with a stroke to the left.

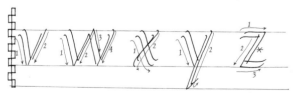

Diagonal letters.
** The diagonal stroke on the letter z is made with the nib at an angle of 10 °– 15° to the horizontal, so that this stroke is not thin and weak.*

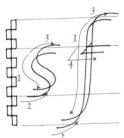

*Those letters which do
not fit into these patterns.*

Practise these letters as before for Round Hand. When you are familiar with their form and stroke sequence, write out these words:

ink nib paper

ultimate pens

And now write out these phrases, remembering to leave the space of an Italic letter **o** between the words:

beautiful writing

one hundred pages

nine nice nuns

21

Here are the same letter families for the Italic hand, written with a pen:

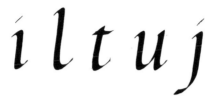

i l t u j

Letters which start with a down stroke.

n r n m
h b p k

Letters which start with a down stroke and then arch. Notice the construction of this letter shape, which is shown at the beginning.

c e o
a a d g q

*Letters which are based on an oval, and start with a stroke to the left. Notice the construction of the letter **a** and related letters.*

v w x y z z

*Diagonal letters. The angles for the three strokes of the letter **z** are shown.*

Letters which do not fit into these patterns. An alternative letter f has been given.

Practise these words and phrases:

minimum untie

the quick brown fox jumps
over the lazy dog

practice makes perfect

You can make your own letter families for Uncials and Black Letter in the four main alphabets shown on pages 33 – 64, and for the additional alphabets shown on pages 72 – 80.

Serifs

When you are used to making the lettershapes, you may wish to add *serifs* to the tops and tails of the letters. Here are some serifs for you to try.

˶ 1 A B d f

Beak serif
The stroke at the bottom of the letters is made by a simple horizontal pen movement. Try not to fall into the trap of making this stroke exaggerated.

D E F h i j

Slab serif

H I J k l m

Hairline serif

K L M n p q

Rolled serif

N P U v x y

Tick serif

Ideas for using double pencils

Writing letters with double pencils is good practice, but the idea can also be put to other uses. Instead of two pencils, tape two pens together and write some letters and words with them. Now try two pens of different colours, and then two pens of different widths. The inside space of the letters, between the lines, can be decorated not just with solid colour but with patterns. These can be made into monograms or used on posters.

Write with pens of different widths or colours. Decorate the inside of the letters with patterns or colour.

Making a card with double pens

Write the initial letter of a friend's name on to paper with two fine point fibre tip pens. Decorate the inside space with a regular pattern. Tear round the letter, not too closely, and mount this paper on to a darker card cut into a rectangle. Finally, mount this on to a contrasting card which is folded in half. The message can be written inside the card, or in tiny letters around the darker card.

You can use letters made with double pencils or pens to make a greetings card for a friend. You do not need a lot of experience before you can put your calligraphy to practical use.

B·I·G letters

This section started with the importance of keeping relaxed and free from tension when writing. For some alphabets, such as Italic, it is almost impossible to make good letters if your hand is held tightly. Double pencils and large letters will help you to loosen up, especially if the letters are so large, 10 cm or more in height, that you need to move your arm to make them.

You can make yourself some large pens to practise letters like this. Large pens are also ideal for writing posters, and large letters can go on a greetings card presented in a similar way to the one above.

Cardboard

The simplest tool for making large letters is a piece of cardboard cut from a cereal packet. With a sharp knife and a metal straightedge cut a rectangle from the cardboard of a cereal packet, or from a packet of tights, or the card used in shirt packets. If you are left-handed, cut the end of your pen so that it is left oblique. Cut on a special cutting mat or layers of cardboard from supermarket boxes. Dip one end of the cut card in ink or watery paint – and write. You may need to keep trimming the edge if it becomes too soggy.

Cut a rectangle from cereal packet or similar cardboard to make a pen. Left-handers should cut their pens to a left oblique shape.

You can use ordinary fountain pen ink, calligraphy ink or paint for this. Pour some into a saucer as it makes dipping in the 'pen' easier.

Balsa wood

You can make large pens from balsa wood. This is very lightweight wood which is obtainable from model and hobby shops. It usually comes in sheets which are 900 mm by 75 mm and of varying thicknesses. It is better to buy balsa wood which is thicker than 1 mm, but if there is nothing else, then two sheets can be stuck together and used.

Cut a rectangle from the wood, using a sharp craft knife and a metal straightedge, again cutting on a mat or layers of cardboard. The wood has a grain direction and it is easier to cut along this rather than against the grain. Left-handers should make their pens into a left oblique shape. Shave across one end with your knife to make a bevel, so that the edge becomes thinner, and then cut straight down to sharpen the pen. This is the writing end, which is dipped into ink to make letters.

Cut a rectangle from balsa wood. *Cut a bevel across one end.*
(Left-handers should cut a rectangle
with one end cut to a left oblique.)

Slice straight down through *Try cutting some notches in the*
the bevel to sharpen the pen. *writing end to make interesting*
 lettershapes.

Try dipping either side of the pen into two different coloured inks or paints. The balsa wood pen can be used again and again, so do not throw it away at the end of your writing session.

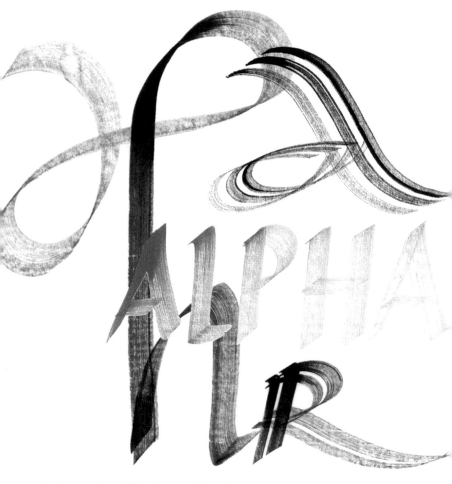

Letters made with balsa wood 'pens'

Because balsa wood is so light, it breaks very easily. You must develop a very delicate touch to use it, and this will help you to relax while you are writing. However, if the pen does break, you will then have two narrower pens!

Large felt pens

For really large letters, where the stroke itself, not just the letters, can be up to 10 cm or more, make your own felt pens.

Cut another rectangle from the balsa wood, although this time the longest side of the rectangle becomes the writing edge. Cover this with a piece of felt and push this into a bulldog clip.

Alternatively, the felt-wrapped balsa wood can be held together with rubber bands. Dip the pen into ink or paint and you will be surprised at what good letters you can make. Try dipping each side into a different colour of ink or paint.

Letters made with home-made felt pens.

When you have finished, take the pen apart and wash and dry the bulldog clip. The same materials can be used again and again, but the clip will rust if it is left wet.

Contrasts

Even at an early stage in calligraphy, when you have learnt just one alphabet, you can use contrasts to good effect in your lettering. A simple change of colour for one letter or word can be quite striking. Look at these examples:

In the beginning

In the beginning was the word,

& the word was with God,

and the word was God.

A change of colour can be very effective.

Another contrast to use in your work is a change of letter size. This is an effective device when a translation is given in another language. Or it can be used to change the emphasis in a poem. When you want the change of letter size to be obvious, then use a nib at least two sizes smaller or larger.

multi fero, ut placem

I have to put up with a lot,

genus irritabile vatum·

to please the sensitive race of poets·

Using different sized nibs for contrast.

Writing lines in capital letters *(majuscules)* and small letters *(minuscules)* in the same piece can emphasise certain sections. You may want to write the heading in majuscules. These do not always have to be large in size. Writing small, but with a lot of white space around the word or line, adds weight. You could use the same size nib to write a repeated word or short line in a poem, or you could choose a much smaller nib for writing majuscules. Do experiment and try out different weights and different sizes.

a time to

WEEP,

and a time to

LAUGH;

a time to

MOURN,

and a time to

DANCE;

Combining majuscules and minuscules in one piece.

When you have practised some of the different alphabets in this book, you may want to combine two of them in one piece. Do this with care. Choose a simply constructed hand, such as Italic or

Round Hand, to use with Uncials, Black Letter or Gothic Cursive. Do not make the mistake of combining two complicated alphabets, as the result will probably not be successful. Aim for a contrast: a narrow hand with a more rounded hand, a plain hand with a fancier one.

2·Four Alphabets

This chapter focuses on the letters of four classic alphabet styles. They are the ones you will probably use most in calligraphy. One page has been devoted to each particular letter of the alphabet, which shows all the four hands.

Before you start, look back at the previous section to remind yourself about relaxing, double pencils, pens and stroke sequences. Bear in mind that it is better to practise letters which are in the same family of strokes, rather than starting at letter **a** and working your way through the alphabet.

Uncials

Uncial letters form the earliest historical alphabet in these four classic styles. They were written in large religious books produced from the fourth to the ninth century. The name *Uncial*, which means one twelfth, was given to them because some letters were so large that they were almost as tall as the width of a thumb. (Twelve thumb-widths, or inches, make up one foot.)

Uncials are wide, round letters. Keep this in mind when you are writing them, and do not skimp on the proportions. They are a capital letter alphabet. If you want to mark the beginning of a sentence, then write that letter a little larger and in a half size, or larger, nib.

This is a majestic alphabet. Use it for important pieces of work, or words to which you want to draw attention.

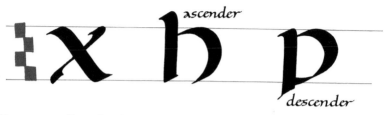

Turn your nib so that it is at an angle of 20°. The x-height is low, 3·5 nib widths. A larger sized pen was used for the letters in this alphabet so that they were of similar size to the other three. Ascenders and descenders are usually very small, only just extending beyond the line for x-height. Keep the spacing between the letters wide as well, and allow a lot of space between lines. It may help to hold your elbow close in when writing this alphabet, or you may choose to cut yourself a right oblique nib, if you are right-handed. This is probably a good hand to try if you are left-handed, as you will not need to twist your wrist so much.

Round Hand

This is based on Edward Johnston's *Round Hand*, or *Foundational Hand*, which he developed from manuscripts written in the twelfth century.

It is a full-bodied hand, written in religious books at a period in history when people were keen to devote time, energy and money to the Church. Make sure that the round letters are round and fat. Remember also to leave sufficient space between the letters, so that your writing looks formal and grand. This hand was used in important books of the period and was written to impress.

Johnston called this hand *Foundational* because he felt that it was a useful style to study at the beginning. Starting with Round Hand will give you a good grounding for the other alphabets. You will be familiar with the letterforms and direction of strokes before you tackle the other hands.

However, your natural style of writing may not suit this hand. You may write naturally in a narrower, sloping style, and to try to force your hand to make round, fat and upright letters at the

beginning could reduce your enjoyment and enthusiasm for the craft.

Try Round Hand first, and if it seems to be causing you great problems, and the letters insist on being narrow and compressed, switch to Italic or Black Letter. You can always return to Round Hand when you are more familiar with the techniques of calligraphy.

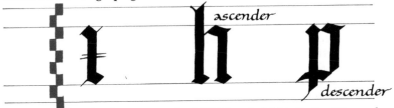

Turn your nib so that it is at an angle of 30°. The x-height is 4·5 nib widths. Ascenders and descenders go above and below the line to about 7 nib widths. The letters are upright. Remember that Round Hand is based on round letters; do not be skimpy when you are writing them.

Black Letter

Black Letter, or *Gothic*, was developed from Round Hand towards the end of the Middle Ages. Books became smaller and more personal, and this hand was used as so much more could be written on one page. However, Black Letter is very difficult to read. This is especially true if words are written in capital letters, or majuscules, only. This is something to avoid.

The key with Black Letter is to try to achieve as much evenness of black strokes and white spaces as possible. It should look rather like a picket fence. It may help to draw vertical lines to maintain a strong upright nature to the letters.

Turn your nib so that it is at an angle of 45°. The x-height is 5 nib widths, and the letters are upright. Ascenders and descenders are only 6 – 6·5 nib widths.

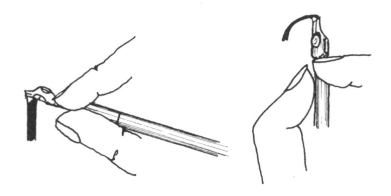

*The hairlines on the letters such as **b h l**, as well as at the end of the top curve of letters such as **f** and capital **C** and **G**, are made by using just the corner of the nib. Make sure that the nib is charged with ink, press the nib down to start the ink flowing, and then pull out a thin line of ink using the corner of the nib.*

Italic

This is a narrow, sloping hand, based on the sixteenth century hands of writing masters such as Arrighi, Palatino and Juan Ycair. It is an alphabet with smooth movement; a cursive hand, without angles. A common fault is to introduce a sharp, triangular shape into letters such as **a d g q**.

It is almost impossible to write a good Italic if you are tense and anxious. If you feel yourself tightening up, then try some relaxing exercises, or use large pens, where arm movement is involved, rather than wrist movement. Look back at pages 26 – 29 for this.

Italic is a very versatile hand, and although the characteristics of the hand are best shown with an x-height of 5 nib widths, this height can be reduced or expanded to suit the piece.

The letters in Italic can also be joined, rather than written separately, for a more informal style. This cursive Italic is shown on page 15.

Turn your nib so that it is at an angle of 45°. The x-height is 5 nib widths, and the letters are written at a slight slope. Rule some parallel lines at 6° to the vertical until you are used to the slope. Ascenders and descenders are long; they can be more than 8 – 9 nib widths. Italic letters are narrow and based on an oval o. They are also smooth and flowing.

Stroke sequence of letters

Pencils and felt tip pens can be pushed around on the paper without too much trouble. However, sharp calligraphy nibs will catch in the paper and spray ink if you try to push them. It is better to make letters in a series of separate strokes, which are usually downwards or pulled to the right. The best direction and sequence for each letter is shown by the coloured arrow and number.

Start with a wide nib. Make yourself a wide pen with cereal packet or balsa wood, or use a William Mitchell size 0 or equivalent large nib, an extra wide felt tip pen, or the widest nib available in a fountain pen set. When you are comfortable with the letters and how they are formed, and have had some practice in writing words, so that you are familiar with spacing, then gradually reduce the width of your pen nib. Writing good and well-formed small letters is more difficult than writing large ones.

The four alphabets

The following 26 pages show each letter of the alphabet in four different styles – Uncial, Round Hand, Black Letter and Italic.

Uncial

Nib angle: 20°

x-height: 3·5
nib widths

Upright angle
of writing

Round Hand

Nib angle: 30°

x-height: 4·5
nib widths

Upright angle
of writing

Nib angle: 45°

x-height: 5 nib
widths

Upright angle
of writing

Nib angle: 45°

x-height: 5 nib
widths

Angle of
writing: 5°–7°

Black Letter

Italic

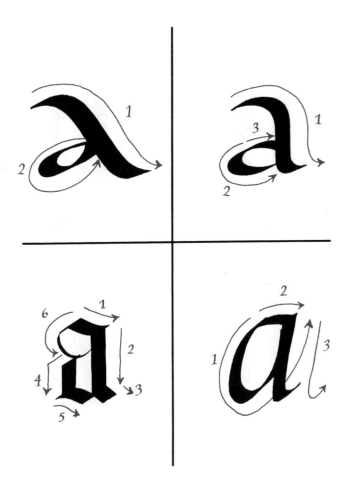

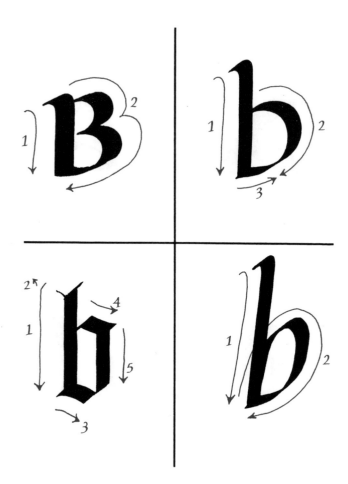

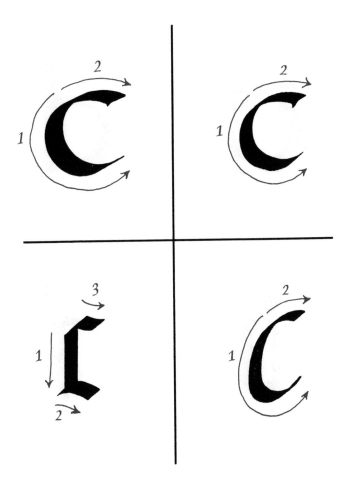

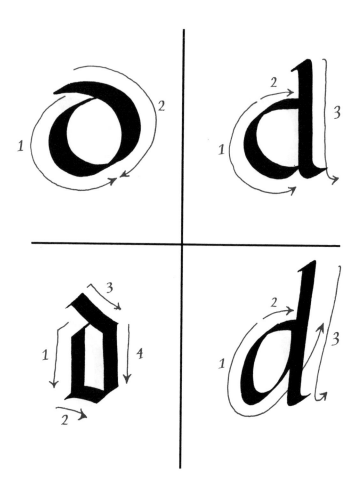

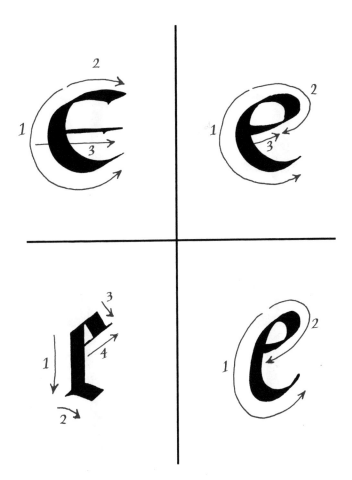

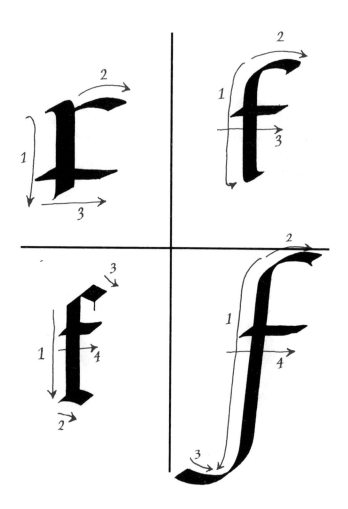

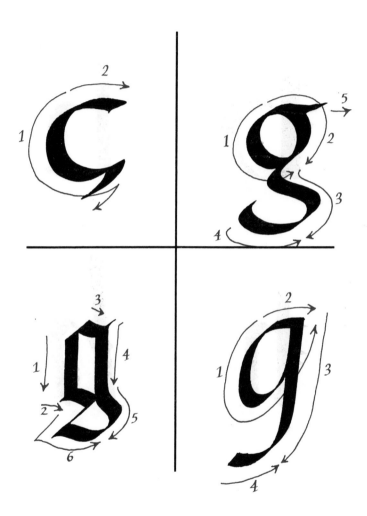

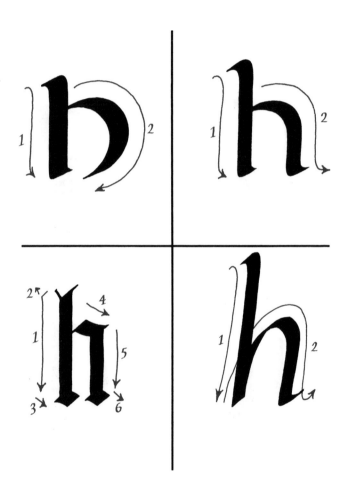

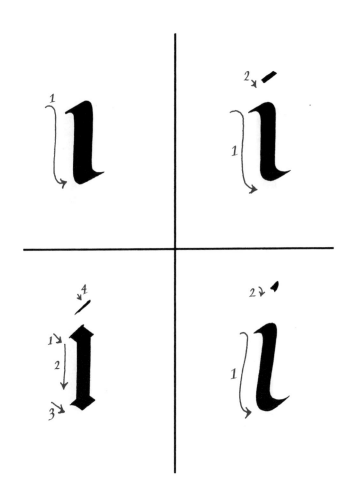

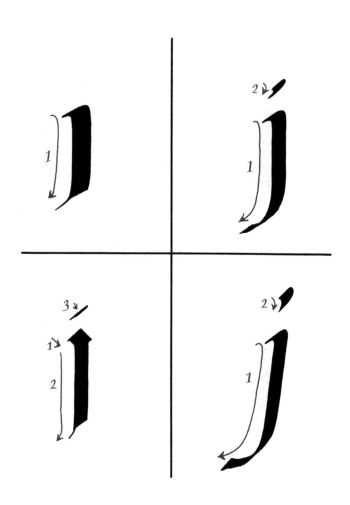

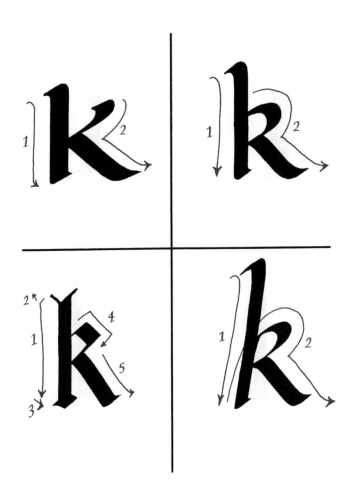

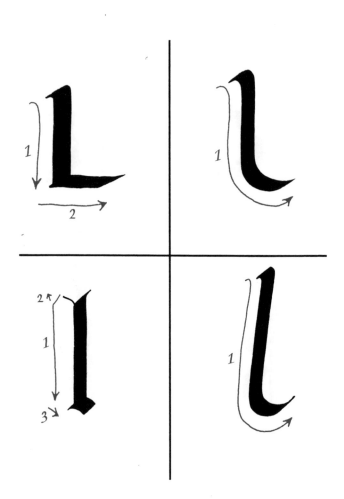

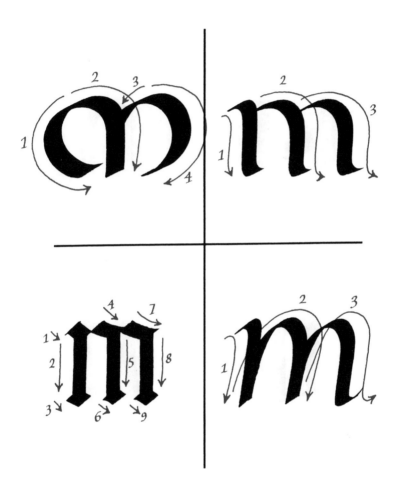

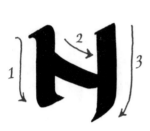

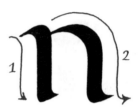

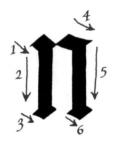

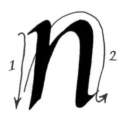

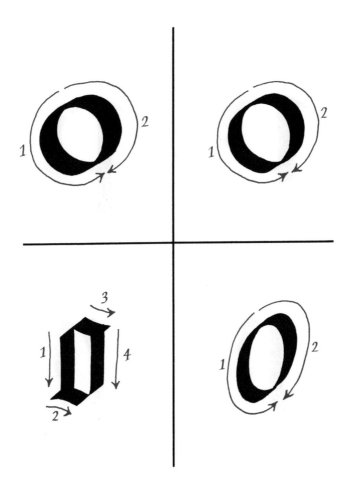

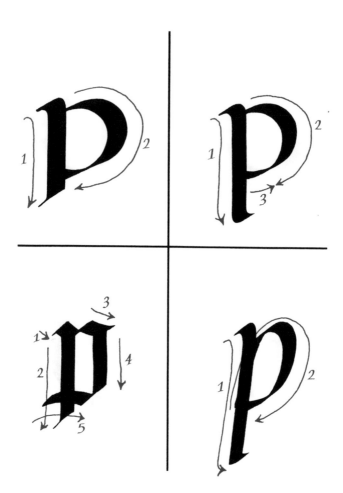

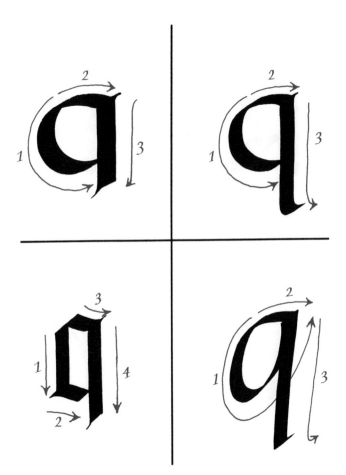

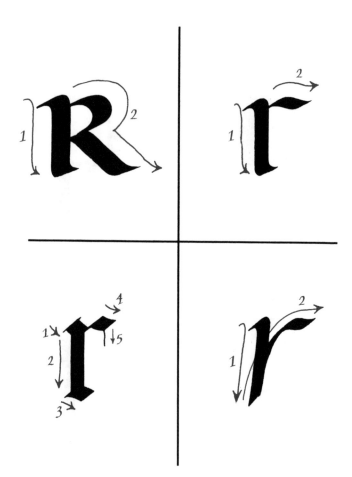

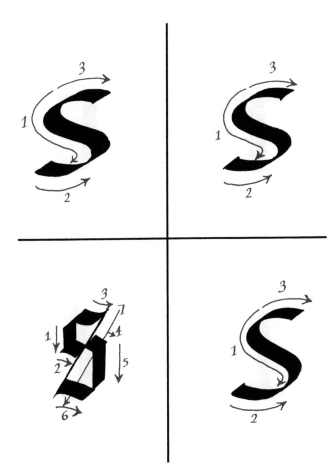

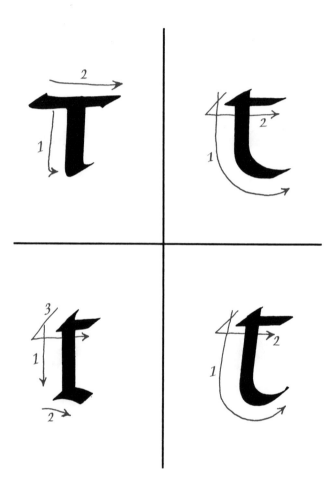

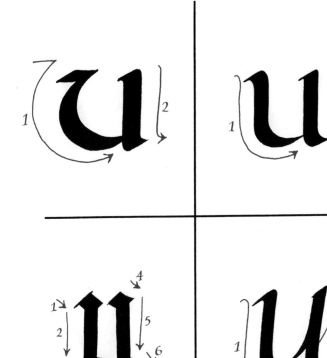

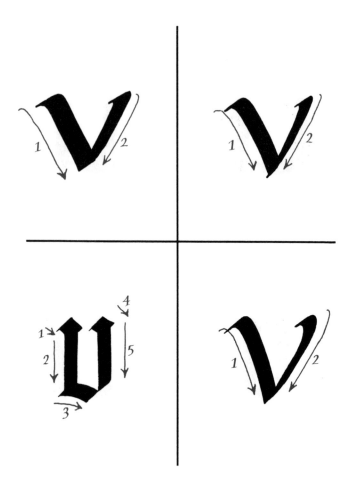

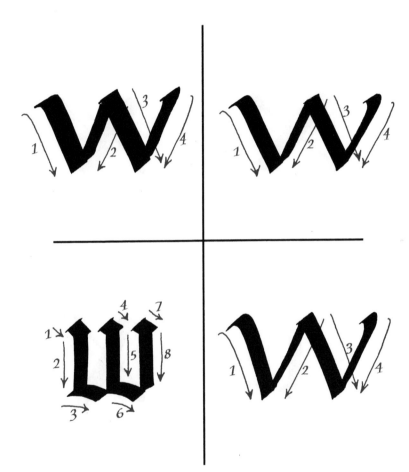

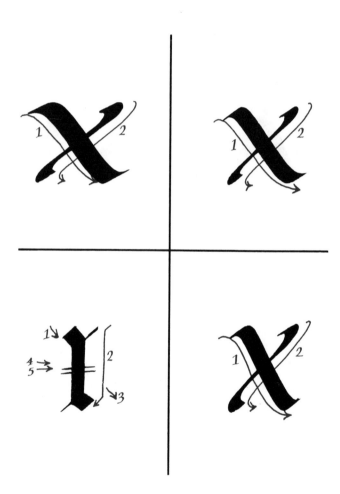

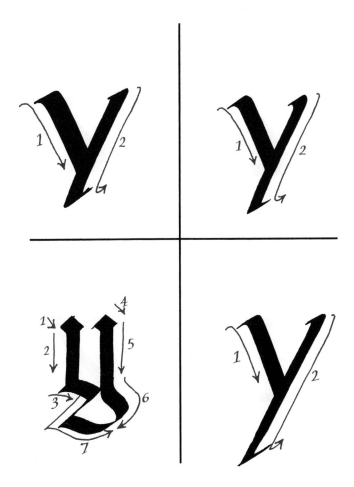

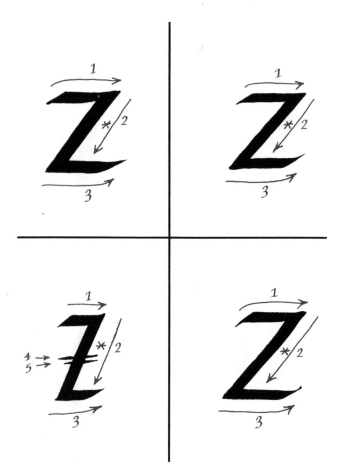

Turn the nib so that it is flatter for this diagonal stroke.

Capital Letters (majuscules)

Capital letter are constructed in a similar way to the smaller letters. In every instance apart from one, the x-height of capital letters is *less* than the height of the ascenders. It is only Black Letter where the capital letters are taller.

The x-height for each capital letter alphabet is given. Practise these letters after you have become familiar with the small letters.

Round Hand

The capital letters to use with Round Hand are taken from the proportions of the classical letters used on Roman inscriptions.

The round letters are based on a circular letter **O**, which can be encased within a square. The letter **Q** is simply an **O** with a tail. The letters **C D** and **G** use the relevant parts of the circle which form the letter **O**.

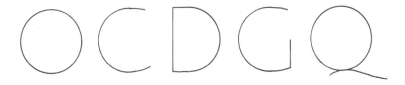

The letter O and related letters are based on a circle.

Letters in the alphabet which are symmetrical are the width of three-quarters of the square which encases the circular **O**. These letters are **A H N T U V X Y** and **Z**.

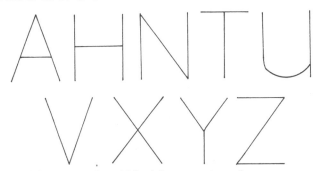

Symmetrical letters are the width of three-quarters of a square.

Asymmetrical letters are half the width of that same square. This includes **B E F J K L P R** and **S**.

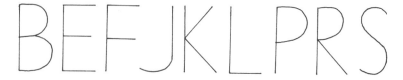

Asymmetrical letters are half the width of a square.

This leaves three letters which do not fit the pattern – **I M** and **W**.

The letter **I** is clearly a single stroke downwards.

The centre strokes of the letter **M** are formed from the letter **V**, and the outer strokes support this. Do not be tempted to splay these strokes so much that an **M** looks like a **W** upside-down. It is actually a surprisingly compact letter.

The letter **W** causes problems. Quite sensibly, the Romans had nothing to do with it on their inscriptions. If two **V**s of normal width are put together, **W** becomes such a wide letter that it makes spacing rather difficult. Calligraphers in the first half of this century tried to resolve the problem by overlapping the two innermost strokes. Unfortunately, this drew attention to the difficult letter, rather than forming a solution. The letter looks acceptable if it is written in four strokes formed of two rather narrow **V**s.

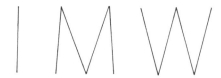

These letters are the exceptions and do not fit the pattern.

Having given the basic outline, most letters break the rules. Strokes are slightly longer or shorter so that letters do not look as if they are about to fall over. The bowls of some letters are smaller than others to give the feeling that they fit in visually. To appreciate this further, Roman Letters are a study of their own. I was told, 'Know the rules but don't always stick to them'.

Round Hand

The proportions for Roman Letters, which are shown in skeleton form on the previous pages, apply to the capital letters of Round Hand.

A B C D E

F G H I J K

L M N O P

Q R S T U

V W X Y Z*

~ *The first and last stroke of the letter* **N**, *and the first stroke of the letter* **M** *are made with the nib at a steeper angle. Turn it to about 55 °– 60° to the horizontal.*

* *Turn the nib so that it is flatter, about 10 °– 15°, for the diagonal stroke of the letter* **Z**.

Italics

Italic capitals follow the same pattern as those for Round Hand. The two differences are that the letters usually follow the *slope* of the small letters (although this is not always the case) and the letters are based on an *oval*, rather than *round*, letter **O**. Given this, the width of symmetrical and asymmetrical letters follow the guidelines.

A B C D E

F G H I J K

L M N O P

Q R S T U

V W X Y Z

~ *Steepen the nib for these strokes*
* *Flatten the nib for this stroke*

B D P R

Alternative letterforms

Black Letter or Gothic

The capital letters of most other alphabet styles are lower in height than the ascenders. In Black Letter the capital letters are taller. Capitals are highly decorated. The patterns of hairlines, flicks, diamonds and swashes fill in the spaces within the letters.

Black Letter forms a dense alphabet on the page – this is why it is called *Black Letter*. Large capital letters, encasing much white space would jar the eye. The scribes developed the decorations to fill in the spaces. The following alphabet is only a suggestion. Look at as many original examples of Black Letter capitals that you can, and develop your own pattern of hairlines and flicks.

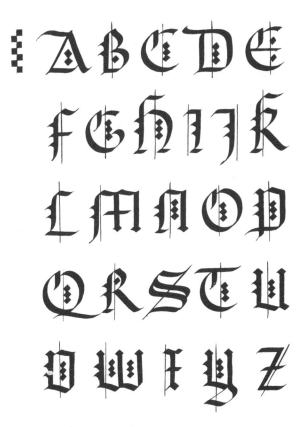

*Flatten the nib for this stroke.

69

WE USE THE LETTERS OF OUR ALPHABET
EVERYDAY WITH THE UTMOST EASE AND
UNCONCERN, TAKING THEM ALMOST AS
MUCH FOR GRANTED AS THE AIR WE
BREATHE · WE DO NOT REALISE THAT EACH
OF THESE LETTERS IS AT OUR SERVICE
TODAY ONLY AS THE RESULT OF A LONG
AND LABORIOUSLY SLOW PROCESS OF
EVOLUTION IN THE AGE OLD ART OF WRITING·

Uncial

We use the letters of our alphabet
every day with the utmost ease and
unconcern, taking them almost as
much for granted as the air we
breathe. We do not realise that each
of these letters is at our service today
only as the result of a long and
laboriously slow process of evolution
in the age old art of writing. McMURTRIE

Round Hand

We use the letters of our alphabet every day with the utmost ease and unconcern, taking them almost as much for granted as the air we breathe. We do not realise that each of these letters is at our service today only as the result of a long and laboriously slow process of evolution in the age old art of writing.

Black Letter

We use the letters of our alphabet every day with the utmost ease and unconcern, taking them almost as much for granted as the air we breathe. We do not realise that each of these letters is at our service today only as the result of a long and laboriously slow process of evolution in the age old art of writing.

Italic

Quotation used by kind permission of Oxford University Press

3·Building on Basics

Versals

Versals are capital letters, or majuscules, and were used in books in medieval times. They are compound letters, made from a number of pen strokes which build up to make a thicker stroke. The proportions of the letters are based on Roman letters, shown on pages 65 – 66, although the letter **O** is not as round. The pen is held vertically to the line to make the thin hairlines and down strokes, and horizontally to make the thicker cross strokes. The down strokes are built up from three strokes: two forming the outside and the third middle 'flooding' stroke. The height of the letters is eight times the letters width, which makes it about 24 nib widths. There is a slight narrowing of each vertical stroke, so that the narrowest point of the letter is just below half way. This is called *entasis*, and helps to make the letters look more balanced. The hairline serifs are not completely straight lines, but should be regarded as being part of a very large circle. Use Versals as headings or to begin a sentence in another hand.

Versals

A B C D E

F G H I J K

L M N O P

Q R S T U

V W X Y Z

Carolingian

Carolingian letters are cursive, sloping letters which are clear to read and a pleasure to write. The letters have a north-east/south-west pull to them, and have long ascenders and descenders. Leave sufficient space between the lines to allow for this. The nib is held at 30°. The x-height is only 3·5 nib widths, so quite a large nib can be used to make small letters. In some ways the hand is a convenient combination of Round Hand and Italic.

A B C D E

F G H I J K

L M N O P

Q R S T U

V W X Y Z

Use these italic-style capital letters with Carolingian minuscules. Keep the nib at 30° and make them slightly fatter than Italic capitals. The springing arches of letters such as **B D P** *reflect the style of the small letters.*

Carolingian

a b c d e

f g h i j k

l m n o p

q r s t u

v w x y z

Gothic Cursive

Gothic Cursive letters developed as a quicker means of writing Black Letter. It is also called *Secretary Hand*. There are strong Gothic elements, which are combined with a flowing cursive feel. The nib is held at an angle of 30° – 35°, and the x-height is 3·5 nib widths. There are many hair lines and flicks, using the corner of the nib. (See page 36 for how to do this.) The hand usually slopes at an angle of about 5° – 10° to the horizontal. Two unusual letters are f and s. Both are very long and at a greater slope than the other letters of the alphabet. The nib is turned so that it is almost vertical towards the end of these letters, thus achieving the thin and narrow stroke. The long s is usually used at the beginning and within a word, the short s at the end, but this is not always the case.

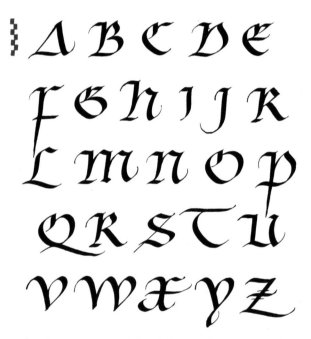

You can develop your own style of Gothic Cursive majuscules to use with the minuscules, based on those of Black Letter. Or you can use these. Gothic Cursive capital letters tended to be wider, rather exagerated and written with panache.

Gothic cursive

a b c d e

f g h i j k

l m n o p

q r ſ s t u

v w x y z

Copperplate

Copperplate uses a springy pointed nib. It is unlike the other alphabets in this book in that the thick and thin strokes do not derive from the broad-edge shape of the nib. Instead, pressure is put on the nib, which releases more ink. You will need to press harder for the downstrokes and release pressure for the other strokes. You will also need far fewer nibs to achieve a range of differently sized letters. The letters on page 93 were all written with the same nib. More pressure was applied as the size of the letters increased. You may find that you can write all the letters you want with just one nib.The pen is also held in the direction of the stroke, which means that the elbow needs to be tucked tightly in to your side. If you find this difficult and want to progress, you may prefer to buy a special nib, which has an elbow joint and means that you do not need to hold your arm in such a way. Copperplate is a sloping, cursive hand, with joins which do not always come naturally. However, it is a relaxing hand to write. Draw parallel lines at an angle of 5° – 7° or even 10° to the vertical until you are used to writing at that slope. This is a good alphabet for left-handers to try.

It is easier to write Copperplate with the paper turned at an angle, and with the board at only a slight slope. Turn the paper so that it is at the same angle as the downstroke.

Copperplate

a b c d e f g h

i j k l m n o p q

r s t u v w x y z

A B C D E F

G H I J K L M

N O P Q R S T

U V W X Y Z

You will have written except-
ionally well if, by skilful
arrangement of your words,
you have made an ordinary
one seem original.

Carolingian

You will have written exceptionally
well if, by skilful arrangement of
your words, you have made an ordinary
one seem original.

Gothic Cursive

You will have written exceptionally well if,
by skilful arrangement of your words, you have
made an ordinary one seem original. *Horace*

Copperplate

Numerals

Numerals are constructed in a similar way to letters, strokes of the pen are pulled downwards or to the right, rather than pushed.

When combining numerals with capital letters or majuscules, it is usual to make the letters and numbers the same height, which, for capital letters of Round Hand and Italic, is 7 nib widths. The numerals do not go above or below the x-height for the capital letters and are called *ranging*.

1234567890

These upright numbers would be suitable for using with Round Hand

Non-ranging numerals are usually combined with capitals and small letters. The numbers **1 2** and **0** are the same height as the x-height for the small letters. Uneven numbers descend below the x-height line, although not usually as low as descenders on letters. The even numbers **6** and **8** extend above the x-height line, although again not as high as ascenders. Through a typographical convention the number **4** usually also descends below the line.

1234567890

These non-ranging numbers which slope forwards could be combined with Italic letters.

Punctuation marks

Match your punctuation marks to the chosen style of writing. A heavier weight looks better with Round Hand or Uncial, a lighter weight with Italic. Turn the nib to a steeper angle to make the punctuation marks less weighty.

These can be used with Round Hand,

and these with Italic.

Ampersands

The ampersand is a very useful device when space is limited. It represents the latin word *et*, which means *and*. Sometimes people do not realise that the ampersand is not just the letter **e**. Always include a stroke for **t** when designing your own ampersands. Again match the ampersand to the style of writing.

This ampersand could be
used with Round Hand, *this with Italic* *and this with Uncial.*

Flourishes

For flourishes to work well, there must be a degree of spontaneity and liveliness in their construction. You may prefer to practise with a felt tip calligraphy pen or a piece of balsa wood to feel the movement first.

Until you are familiar with their use, flourish with restraint. Here are a few ideas for flourishing capital letters. Look at manuscripts and pieces of calligraphy to extend your knowledge of this area of the craft.

Flourishes should grow from an existing stroke, rather than be grafted on in a contrived way. Not all letters flourish easily because of this. The letters **C O** and **S** are difficult to flourish; here they have been simply written larger.

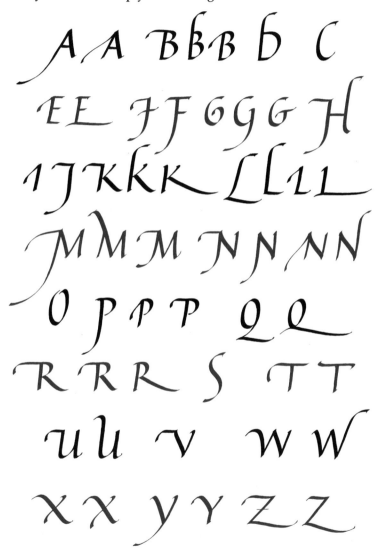

Flourished capital letters

Ascenders and descenders can be flourished, too. Again the flourish should arise naturally out of the stroke. There should be no jerky movements or awkward corners and bends. Try to make the parts of the flourish balance.

Here are some simple ideas. Try them first, and then work out some of your own.

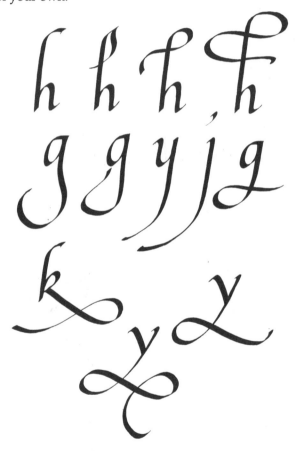

Flourished ascenders and descenders.

4 · Tools and Materials

Starting calligraphy can be as expensive or as cheap as you wish to make it. You can buy a top-of-the-range sloping board, which adjusts to a variety of angles and has a sliding parallel rule, a dip pen with a full set of nibs, Chinese stick ink and an inkstone, and a range of different pens and nibs. Or you can devise a sloping board using a large tray, cut a rectangle from a piece of cereal packet to use as a pen, dip it into a cheap bottle of fountain pen ink, and not commit yourself to any purchase until you are sure that calligraphy is something which you like and enjoy.

This section deals with a range of tools and materials which you can use.

Pens

Many letters in calligraphy are formed with a broad-edge nib, or some sort of a device which mimics this. A rectangle of cereal packet, two pencils taped together (see pages 3 – 4), a balsa wood pen (see pages 27 – 28), or a carpenter's pencil can be used instead of, or as well as, recognised pens. They will all produce lettershapes which have thicks and thins, and, in addition, will ensure a good start to the craft, because the letters produced will be large. Large letters show the lettershape better.

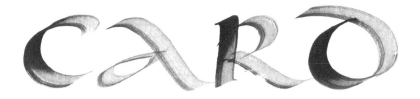

Letters produced by a piece of cardboard,

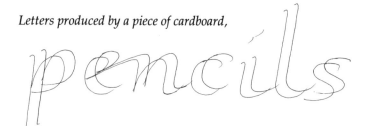

two pencils,

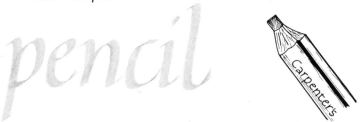

and a balsa wood pen.

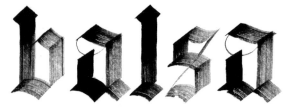

A carpenter's pencil has a rectangular lead, and each of the four sides should be trimmed to a sharp edge. Finally, the top is levelled off so that you can make sharp letterforms. The graphite is normally graded, similar to other pencils, and it may be better to choose a harder H point rather than a softer B point, which will need sharpening more often. You can buy carpenter's pencils from some calligraphy suppliers, or from hardware shops.

Calligraphy felt pens and fountain pens

You may wish, however, to use a calligraphy pen early on. It is much better to begin with something which you find easy to use. This may be a cheap calligraphy felt tip pen, or a calligraphy fountain pen from a set. Or you may wish to write with a calligraphy dip pen. It is more important for you to be relaxed and enjoy what you are doing than to be struggling with the writing equipment.

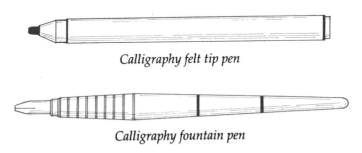

Calligraphy felt tip pen

Calligraphy fountain pen

The advantage with calligraphy felt tip and fountain pens is that they are easy to use at any time. There are no nibs or reservoirs to slip on and off and they do not require special inks. In fact, felt tip pens do not need to be filled with ink at all, and any fountain pen ink can be used in fountain pens. They are also widely available. However, there is only a limited range of nib widths, and colours are fairly restricted, too. Although it is possible to sharpen fountain pen nibs to a limited extent, they are rather inflexible to use, and at some point you will probably be dissatisfied with the lack of sharpness in the letterforms from these and felt tip pens.

Calligraphy dip pens

You can achieve very crisp letters with the nibs of a dip pen. Nibs, reservoirs and a penholder can be bought separately, but they are usually sold as a set of nibs, reservoirs and a pen holder.

Calligraphy dip pen

The penholder you buy will probably have a central core, either metal or plastic. The nib is held between this core and the teeth. Nibs should be pushed in firmly. A nib should not move about when you are writing. Take the nib out and put it in again firmly if it does.

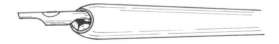

The nib goes between the central core and the outer pen holder.

Nibs

In the past, nibs used to be covered with a thick layer of shellac, which sometimes prevented the nib from working properly at first. Nibs bought recently do not seem to have this problem. However, if the nib you start to use does not seem to write easily, wash it briefly in warm water. A few scribes recommend passing the nib through the flame of a match. I stopped suggesting this method when one of my students mistimed this and melted the nib! If a pen is being really troublesome, then put some saliva on to a finger, and rub the nib on this. It sounds unpleasant, but it does work.

Always start your nib working by going back and forwards, making a thin stroke. When the ink is flowing freely, then the thicker strokes can be made.

You can buy nibs which are produced for right- and left-handers. Some types of nibs are sold complete with a reservoir which sits on top of the nib.

Square cut nibs for right-handers *Left oblique nibs for left-handers*

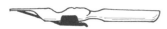

William Mitchell nib, *the reservoir fits under the nib.*

Brause nib, *the reservoir sits on top of the nib.*

Reservoirs

The slip-on reservoir is made of very flexible metal. It should be slid under the nib and go on easily without dropping straight off. If it falls off, bend the side lugs so that it grips the nib better. If the reservoir grips too tightly, then loosen the side lugs. Hold the pen and nib up to the light. The reservoir should not be so tight that it pushes apart the two sides of the nib. This is less likely to happen with wider nibs, but with narrower nibs a too tight reservoir will result in letters with two strokes. Take the reservoir off again and bend the central section back a little if it is too tight. The reservoir should touch the nib, as its purpose is to feed the ink into the nib. If it is not touching, it cannot do its job properly. At first, putting a reservoir on may seem rather fiddly and time-consuming, but very soon ensuring that the reservoir fits properly will become almost automatic.

The slip-on reservoir slides under the nib. It should touch the nib, about 2 mm from the tip.

Some older-style pen holders have a reservoir strip of metal attached to the holder, rather than separate, which will help if you find fitting a reservoir difficult.

For narrower nibs you may not need a reservoir at all. Some calligraphers dispense with a metal reservoir altogether, and cut a tiny strip of masking tape, about 2 mm wide, which is wrapped around the nib and acts as a reservoir, feeding ink into the nib. This may be more trouble than getting the reservoir to fit properly in the first place, but is worth trying if you really find fitting a reservoir difficult.

Feeding in the ink

Although they are called *dip pens*, the best results are *not* always obtained by simply dipping in the pen and writing. Ink should be fed to the pen with a brush. Dip a cheap paintbrush into the ink, and gently stroke the brush along the side of the nib. The ink should collect between the nib and the reservoir and flow easily whilst you are writing. You will need to charge the pen frequently when writing with a large nib, but can write a few sentences with one brush load when using a small nib. Although filling the pen can be frustrating at times, do not fill it too full. The next letter you write will be sure to flood.

Some scribes prefer to dip their pens into ink, and then wipe the back of the nib on a piece of kitchen roll, a tissue or small scrap of cloth. However, this can be as time-consuming as filling your pen with a brush.

Dip an old paintbrush in ink and fill your pen by stroking the brush on the sides and underneath the nib.

Washing the pen

At the end of a writing session, take the reservoir off the nib, and pull the nib out of the pen holder. Wash both carefully in water, scrubbing gently with an old toothbrush if necessary, to remove all traces of ink or paint. Dry the nib and reservoir, and replace them in the pen holder or with your box of nibs. Ink can be

difficult to remove when it has dried on the nib, and you will not get good, sharp letters with a nib which has caked-on ink. Washing the nib while it is still in the pen holder will result in both nib and penholder rusting. If you take care of your writing equipment it will last longer and save you money. Metal nibs last years, even with frequent use, if they are looked after properly.

Sharpening nibs

Even new nibs do not always produce good, crisp letters on certain papers and almost all nibs write better when they are sharpened. It is even worth sharpening calligraphy fountain pens nibs to make better letterforms. Although it may sound a little drastic, sharpening nibs is not difficult, nor does it ruin them.

The best stone to use is an Arkansas whetstone. This is a very smooth, almost white, stone, which is available from some specialist tool shops (an Arkansas whetstone is used to sharpen tools, too), or some jewellry suppliers. The smoother side of an India sharpening stone from hardware shops can also be used to sharpen nibs (but do not add oil to the stone, as you would if sharpening tools), or you can even use very fine sandpaper. Clearly the smoother the sharpening material, the sharper your nib will be.

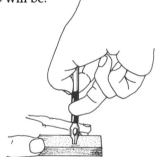 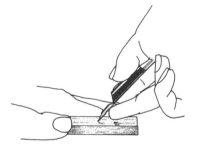

To make sure that the writing edge is straight, stroke the nib 5 – 7 times back and forwards along the stone.

Supporting the back of the nib with a finger, stroke the back edge of the nib on the sharpening stone for about 5 – 7 times.

Look at the edge where you have just sharpened. It should look smooth and shiny. It may help to examine the nib under a magnifying glass.

To make sure that there are no metal burs remaining on the nib as a result of sharpening, which could spoil your writing, give both sides of the nib and the top front edge one stroke on the stone. This should remove any roughness.

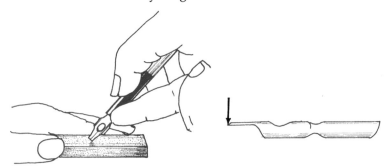

Remove any metal burs by stroking the sides and top of the nib on the stone.

You are trying to achieve a straight, sharp edge for writing clean and crisp letters.

Now try the nib on the writing surface. It should write easily and give a good, crisp edge to the letters. If not, re-sharpen. If the nib is too sharp it may actually cut the paper, in which case carefully stroke the front edge of the nib again on the stone to dull it. Nibs do need to be re-sharpened after a while. Do not put up with poor quality letters for the sake of sharpening a nib.

Different nibs

Cardboard, balsa wood and home-made felt pens are not the only pens available for making large letters, or letters with more than one stroke. Here are some other nibs and pens.

These nibs have a reservoir above the nib, with a slightly upturned edge so that the pen can be used on textured surfaces.

Split nibs, with different thicknesses, produce letters with two strokes.

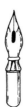

Nibs with five lines can be used for ruling music staves – but also for letters.

Copperplate nibs have a pointed end which is very flexible. One nib can produce different sized letters simply by pressing harder. All these letters were made with the same nib.

Automatic and coit pens

Automatic and coit pens produce large letters – up to 2·5 cm wide. Some have nibs with slits and notches which produce letters with more than one stroke. They are available from specialist calligraphy suppliers. You can write with both sides of a coit pen, but always make sure that the tiny slits are uppermost with automatic pens.

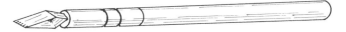

Automatic pens

Coit pens

Reed and bamboo pens

At some point you may wish to cut your own pens. It is not difficult to do, although some scribes sometimes tend to surround quill cutting with an air of mystique. It does, however, take a little practice to perfect. Essentially what you are doing is shaping a nib at the end of a cylinder. Look at an ordinary dip pen nib – this is what you are wanting to copy.

Bamboo canes are easily obtainable from garden centres or suppliers. Reeds or even the dried stems of plants like artichokes can be collected from a known source.

Select stems or bamboo canes which are between 0·75 and 1·5 cm thick, and cut them to lengths which are approximately pen size, about 20 cm long. Choose the end away from the bulge for bamboo, and, when cutting for the very first time, choose the pieces that feel the lightest, as they have the least moisture and are easiest to cut. You will need a heavy duty craft knife for cutting bamboo pens; scalpels and similar knives are not robust enough.

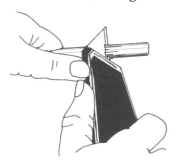

Make a long scoop cut in one end of the bamboo. Scrape out the pith.

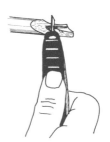

About halfway along this cut, make two cuts on either side of the bamboo. The shape of the nib is now being formed.

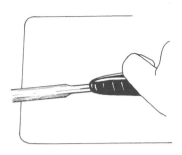

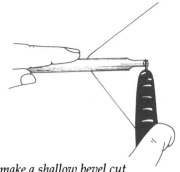

Make a slit down the middle of the nib, about 1·5 – 2 cm long.

Next make a shallow bevel cut across the top of the nib shape.

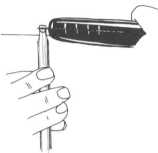

Last of all, slice down through the very edge of the nib. This sharpens the nib.

Bamboo pens soak up a lot of ink at first, so use a watery ink or paint when starting to write. The pens can be re-used, simply rinse them under a tap and dry on a piece of kitchen towel. If the bamboo seems dull and does not make good letters, take another slice down the front of the nib. At some point you may need to cut another bevel and then a slice.

Reed and other pens are cut in the same way.

Quills

A quill can be cut from almost any suitable feather. Tiny letters and very fine lines were written and drawn with a crow quill in medieval manuscripts. Nowadays swan, goose and turkey feathers are the ones mostly used. These can be obtained from specialist calligraphy suppliers, during the moulting season from

a bird sanctuary or ponds and lakes which have geese or swans, or from a friendly butcher. Each Christmas I collect a sack of the first five flight feathers (although the first and second are best) from the wings of turkeys and geese from our local butcher. These are then used by my students, and, as they are free, students are quite happy to experiment with cutting quills on these feathers.

Some professional scribes think that it is important to use feathers from birds which are allowed to roam freely. I have used feathers from our own geese, which are free range, and from Christmas turkeys, which are not. The difference to me is not between free ranging birds and those which are factory farmed, but between the individual birds themselves.

Right-handers should use feathers this shape as they fit into the body and arm better;

left-handers this shape.

The popular view of writing with a quill is that the scribe writes with a long, fully barbed feather. In practice, most of the barbs are removed and the feather cut to a much more manageable pen length. You may wish to leave a couple of feathers as they are when you are demonstrating with a quill. People seem rather disappointed when they see a 'real' quill.

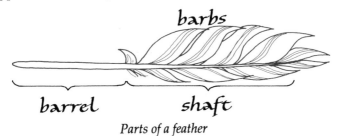

Parts of a feather

There are two stages to making a quill – curing or hardening and cutting. Feathers do harden naturally over a number of years, but you may wish to use your quills before this, in which case they need to be cured with heat. There are two ways to do this. The more usual way is to use heated sand, the second method is to use a dutching tool.

Preparing feathers
For either method, the feather needs to be prepared.

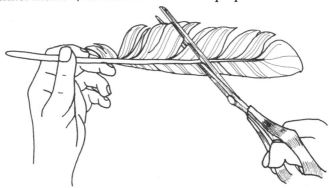

Cut a feather to a reasonable length, about 20 cm, and pull off the barbs. Use scissors to cut those barbs closest to the barrel so that they do not tear the barrel wall.

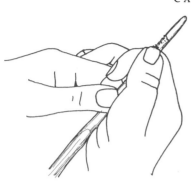

Scrape off the outer coating of the barrel, using a fingernail or the back of a knife.

Cut off the very end of the feather with scissors or a knife.

With a small crochet hook or knitting needle, pull out the inner dry membrane from the barrel.

The feathers now need to be soaked in water in a jam jar to a depth of about 5 – 6 cm for approximately six to eight hours, or preferably overnight.

Curing quills

Curing quills involves trial and error, even for the skilled quill cutter. Because they are a natural material, the feathers themselves vary in thickness and thus need longer or shorter times for curing. Exact times are impossible to give.

If you are curing quills using hot sand, you need a small quantity of fine white sand – the sort used for sand pits, or silver sand, available from builders' merchants. Unfortunately, builders' merchants usually want to sell this sand by the sackful and you only need enough sand to fill a dish to a depth of about 4 – 5 cm. Put the sand into an ovenproof container, such as a deep pie dish, and place in an oven with the temperature set at 350°F, 180°C or Gas Regulo 5 for 25 minutes, so that the sand is heated thoroughly.

The feathers to be cured should now be removed from the water, dried on a cloth or pieces of kitchen towel, and water from inside the barrel shaken out vigorously. The remaining feathers can be left in the water.

Remove the dish containing the sand from the oven, place it on a heat-resistant mat and plunge a feather into it, trying to push some of the hot sand into the barrel. Use a teaspoon to pour some more sand into the barrel if necessary. After 10 seconds remove the feather. If the sand is too hot, or you have left the feather there for too long, the feather will blister. If the sand is too cool, or you have not left it in long enough, the barrel will still be soft and rubbery. If the timing and temperature are right, then the milky colour of the barrel will have become almost clear and yellowish-amber in colour and it will be very hard and robust, rather like a very strong finger nail. Once conditions are right, then you can cure five or six feathers at a time.

Because heating sand and preparing feathers is time-consuming, it is always better to cure a number at a time. Also, as feathers are different, even from the same bird, you will find that you have to discard a few after they have been hardened. The best feathers for quills are those which, once cured, are hard and clear, and where it is very difficult to squeeze the sides of the barrel together because it is so tough. If this is not the case, try plunging the feather into the sand again for a few seconds. However, if this does not work, throw these feathers away, as they will be too soft to cut a decent nib.

The sand needs to surround the feather, inside and out. Use a teaspoon to pour sand into the barrel.

The second method of curing quills uses a dutching tool. These cannot be bought, but must be made. I was particularly fortunate in having a dutching tool made for me by the eminent letterer John Woodcock, who also showed me how to use it.

The dutching tool is made from a brass cup hook.

Carefully hammer out the hook until the end is straight.

File until the shape is triangular.

Finally file the end to a dull point.

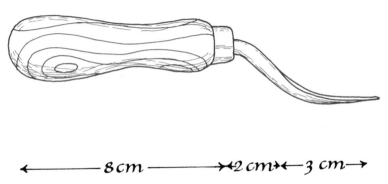

The dutching tool can now be mounted into a wooden handle for ease of handling and for safety.

The feathers are prepared as before – cut to a pen length, barbs pulled off, end removed, membrane inside and out of the barrel taken away, soaked in water for five to six hours and then dried. Each feather is cured individually, and as the process is much simpler, it is not necessary to cure so many at a time.

The heat for curing is provided by an ordinary domestic iron. There is much more control over the curing process with this method, as the feather can be removed from the heat source at any moment.

Put an ordinary domestic iron
on its end, and set it to 'one dot'
or a low setting to heat.

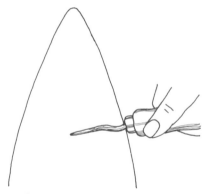

Place the dutching tool against
the hotplate of the iron and let
it heat for a couple of minutes.

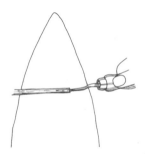

Rotate the feather against the
hotplate of the iron with the
dutching tool inside the barrel.

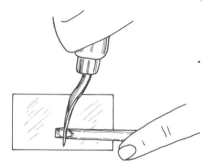

Press the heated feather, which
will feel 'gummy', on a cool metal
plate, such as a metal rule, so that
the barrel becomes oval shaped.

With a dutching tool the barrel of the feather can be made into an
oval shape which will produce much wider nibs than is usual
with conventionally cured quills. The control over curing the
feathers, and the ease by which it is done, makes curing quills
with a dutching tool the much preferred method.

Cutting quills
Once feathers have been cured or hardened they can be cut into
quills. Again, this is simply making a nib shape at the end of a
hollow tube.

You will need a strong knife to cut a quill, as the feathers are tough when they have been cured. Some scribes prefer to use a knife with a straight edge. I was taught to cut quills using a knife with a curved blade – similar to a penknife blade (which, after all, was the original purpose of the knife). If you choose to use an ordinary penknife, the blade will need to be sharpened on a whetstone for quill cutting.

I use a craft knife with disposable curved blades, which slot in and then are screwed to secure them. When the blade becomes too blunt for quill cutting, I transfer it to another craft knife and use that for cutting board or paper, or pencil sharpening, replacing the blade in my quill knife with a new one. You could use scalpel knives with a curved blade, but I find these knives rather lightweight and not substantial enough for quill cutting.

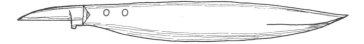

A knife with a straight blade preferred preferred by some scribes.

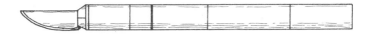

A knife with a curved blade for quill cutting which I prefer.

The method for cutting quills is similar to cutting reed or bamboo pens, and, unless you have a good, cheap supply of feathers, it may be best to practise on bamboo or reed before you cut a quill.

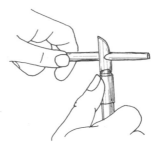

Make a scoop cut along the top of the feather. This is the top of your nib.

Turn the feather over and make another scoop cut about 3 cm long.

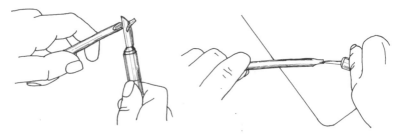

Make two cuts on either side of the previous cut so that the width at the end is approximately the width of the nib you require. You are now starting to shape the nib.

Now make the slit down the pen. Hold the quill as shown, and make a small slit with the knife.

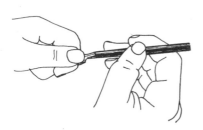

Place your thumbnail where you want the slit to end. Push the end of a small paintbrush into the barrel of the quill, and gently lever it upwards. The small slit made with a knife will lengthen, and should stop at your thumbnail.

Alternatively, you can drill a hole with a very fine jeweller's drill. The hole will prevent the slit going any further. The slit should be about 1 cm for ordinary writing, but about 1·5 cm if you are using the quill to lay gesso for gilding.

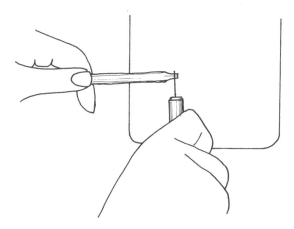

Then cut straight across the end of the nib. This is where the curved blade comes into its own. A curved blade can be 'rocked' on the end of the nib, making this process quite simple and easy.

It helps if you look at the nib under a magnifying glass to check that the edges are sharp and clean. Try the quill, it should write easily, with a very light touch – it is, after all, featherweight!

If the quill needs trimming or sharpening again, simply take a tiny slice across the end of the nib. At some point you will need to cut another bevel off the top of the nib and slice straight down again to sharpen. You will find that quills need sharpening more often than metal nibs.

Reservoirs

For wider nibbed quills you may prefer to insert a reservoir. There are a number of ways that you can do this. Simply attaching a metal reservoir with masking tape is effective. Or you can use a 2 mm strip of masking tape wrapped around the nib; this acts as a reservoir. However, you can also make your own reservoirs with a strip of soft metal. The easiest source of supply is the top of a soft drink can. The metal used for the top of the can (not the ring pull!) is soft enough to cut with scissors – but do take care when cutting it away from the rest of the can. From the top of the can cut a strip about 2 – 3 mm wide and 3 – 4 cm long. Bend this into the shape of a curvy letter **s**, snip the edges off the two corners and insert it into the quill with this end touching the nib.

Put the home-made reservoir into the quill so that the end of the s-shape with the trimmed corners touches the nib. This will then feed the ink to the nib. If it does not touch the nib it cannot do its job and will not work. The rest of the s-shape holds the reservoir in place. You may need to take out the reservoir and re-bend it to make it fit properly.

Keeping quills
Writing with the quill straight after it has been cut should present no problems. If you leave it for a while, however, the quill can dry out and the two ends of the nib will separate. To prevent this happening, wrap the quill in dampened cotton wool or a piece of kitchen roll, and cover this with a small strip of cling film. Leave it for a couple of hours, or preferably overnight. Do not make the cotton wool too wet, or it will soften the quill too much so that it cannot write properly.

Other pens

Almost any implement which will hold ink can be used as a pen. Do not think that you can use only those tools which are conventionally regarded as pens. Sticks and twigs from the garden or woods can be put to good use, so can the 'wrong end' of feathers. Dip these in ink and write letters. You can cut a nib-shape at the end of a stick or twig, or simply use it with a rough edge to make letters with an unusual texture. Try cutting pens out of polystyrene or piano felt (follow the instructions for making balsa wood pens on pages 27 – 28), plastic tubing used for plumbing, obtainable in hardware stores (follow the instructions for cutting bamboo pens on pages 94 – 95), and any other *found* materials.

Letters written with sticks, twigs, plastic tubing, a natural sponge, a ruling pen, the barbs of a feather, piano felt and foam rubber.

Brushes

Brushes can also be used as pens. Those which mimic the thick and thin of a broad edged nib are usually referred to as one-stroke brushes. It is thought that the inscriptions cut into stone by the Romans were first drawn out using a one-stroke type brush. Try writing Roman Capitals with a brush and watery ink or paint. For very large letters which you could use for a poster,

107

you can use ordinary home decorating paintbrushes. Pointed brushes also make lively and vigorous letters but almost any brush can be used to make letters.

Letters made with an ordinary home decorating paint brush, a pointed brush, a stencil brush, a one-stroke brush and even a toothbrush!

Ink and Paint

Liquid Ink

You can use *almost* any ink for calligraphy. Fountain pen ink obviously works better in fountain pens; it may be a little watery

when used with dip pens. Ink which is waterproof usually contains shellac which will clog the nib. It is best to avoid any ink which has the word *waterproof* on its packaging.

Some of the inks which are sold specifically for calligraphers can be rather sticky and difficult to use for beginners. If you have bottled ink like this, shake the bottle well and add a little water to it. Your letters may appear a little weak and watery, but at least the pen will write. Once you have got used to writing with the pen, then you can reduce the amount of water. However, if the ink is old, you may still need to add water to it.

Liquid Chinese and Japanese inks are very suitable for calligraphy, and usually give a beautifully smooth writing medium. A bottle of this type of ink should last a long time. They are obtainable from specialist suppliers, and sometimes from shops which concentrate on Chinese or Japanese goods of all kinds.

Chinese and Japanese stick ink

At some stage you may wish to try Chinese or Japanese stick ink. This is black ink, or a limited range of colours, which are in solid sticks. The ink needs to be rubbed, with a small amount of water, on a surface which has a slight texture to it – either a special inkstone, or a piece of ground glass.

You can mix small amounts at a time as needed, so it is very economical to use. The ink not used can be decanted into a small jam jar, but it does not seem to keep for any length of time. Ink that I have used goes rather grainy after a week or so. However, sticks vary, and you may find that you are able to keep mixed ink for a lot longer than this.

To mix batches of ink which have the same consistency, count the number of drops of water which you need to use to mix the ink. Also, take a note of the time you spend grinding the ink. Repeat the amount of water and grinding time to achieve the same density of ink.

The advantage with stick ink is not only in its smoothness and writing quality, but also in its portability. You can carry stick ink and an inkstone with you to workshops and demonstrations without having to worry about pots of ink spilling in a case.

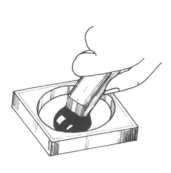

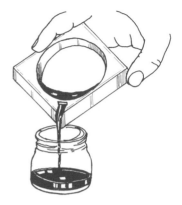

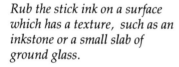

Rub the stick ink on a surface which has a texture, such as an inkstone or a small slab of ground glass.

Decant the ink into a small bottle, or you can use the ink straight from the inkstone, although it does dry out rather quickly.

Coloured stick inks need to be mixed to a slightly thicker consistency than black to achieve letters which are even and not patchy. You will also need another inkstone or piece of ground glass for grinding coloured stick inks. Black is so dominant that it will make the colours murky if you try to grind colour in the same place as you have mixed black.

When you have finished grinding the amount of ink you require, the inkstone must be scrubbed clean with water and an old toothbrush. Old stick ink will flake and make a new batch of ink gritty.

Paints

Gouache

I recommend gouache for people beginning calligraphy. Gouache (pronounced góo-ash) comes in tubes, and is a paint, like watercolour, but contains chalk or similar material which makes it opaque. Tubes can be bought from art shops, and come in a wide range of colours. Jet black is the best black to use, and is what I use when Chinese stick ink is unsuitable for the writing surface. You can add a drop of ox gall liquid to the paint to help it flow more easily through the pen, and a drop of gum arabic to prevent the paint from rubbing off the surface of the paper, but it is unlikely that either will be needed very often.

A new tube of gouache could have some gum at the top when the lid is unscrewed. Squeeze this out and wipe it on a piece of tissue or a kitchen towel.

Then squeeze out about 1 cm of the coloured paint into a saucer, paint palette, or shallow container. White is the best colour for the container because it shows the colour at its truest hue.

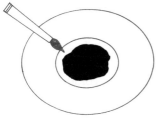

Using an old paint brush, or a child's really cheap paintbrush, mix the paint with cold water until it is the consistency of thin cream, or 'top of the milk'.

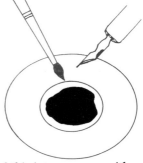

Feed this into your pen with the brush used to mix the paint.

If you do not use all the gouache you have mixed, cover the saucer with another, or with a piece of clingfilm to keep out the dust. When you are ready to use the paint again, add some water and re-mix to the best consistency.

Try out other colours as well as black. You will be surprised at how different your calligraphy looks when the writing is in a colour. Mix the colours together to make new ones. Some colours of gouache can be rather grainy in texture, and, if you can, it is best to try out the colours for writing. This is not always possible, and therefore you may wish to use these colours first as they do

write particularly well:

> green – *oxide of chromium*
> red – *scarlet lake or red ochre*
> blue – *ultramarine or indigo*
> purple – *light purple or purple lake*
> yellow – *sunshine yellow, lemon yellow, or Naples yellow*
> white – *permanent white*
> brown – *burnt Sienna*

Of course this list is by no means exhaustive, and this is not necessarily the best *colour* range (ultramarine, for example, is a quite startling blue!), but it does gives a range of colours with which to start to write.

Poster Colour

Poster colour is similar to gouache in that it is opaque. It is also very cheap. Pots of poster colour, or round tablets of colour can be bought in most art shops and stationers where children's painting sets are sold. It is not as smooth as most gouache, and it is difficult to achieve good density, but is worth trying if you want to experiment with colour, and are not sure about buying tubes of paint. Simply add water to the poster colour until you have the density you want, and feed the colour into your pen.

Watercolour

You can use watercolour for calligraphy. Watercolour is transparent, and so the letters you write will not be solid colour. However, this can be most effective for some pieces, and the end result is very pleasing. Mix the colour as for gouache, but you will not be able to achieve a thick consistency. Watercolour *is* watery.

Concentrated watercolours are also worth considering using as ink, and, as they come ready mixed, avoid the need for saucers and mixing brushes. Most are sold in bottles with a dropper contained in the lid, so that the paint can be fed straight into the nib from the dropper. You do need to experiment with the colours, however, as some shades bleed and make spidery letters when passed through a nib.

Paper

When starting calligraphy, it is best to choose the cheapest paper you can buy. Practising patterns and letters with a large size nib uses a lot of paper, and it is not really worthwhile to use an expensive paper at the beginning.

Most cheap *photocopying paper* is good for writing, especially A3 size. These larger sheets are better as you will not need to draw lines so often.

If you have a source of supply of *computer paper*, then use this. This paper has a good *tooth* to it, which means that the pen does not skate over the surface, and it has the additional advantage of having lines already drawn on it. They may not be at the exact width you require, but will reduce the number of lines you have to draw.

Another good paper for the calligrapher is *layout paper*. Pads of layout paper are available in most art shops; again choose larger sheets, A3 or A2. This paper is slightly transparent, and means that you can place a sheet of letters underneath the paper you are using and trace through the sheet. Many professional calligraphers use layout paper for working out a project because it is relatively cheap and reacts so well with the pen.

Although it does not have a particularly smooth surface, *wallpaper lining paper* is cheap and readily available at do-it-yourself and home decorating shops. If you are practising big letters with double pencils, automatic or coit pens, then this may be the best paper for you to use.

Home decorating shops often sell off rolls of *discontinued wallpaper*. As long as this is not ready pasted, this paper is also cheap and suitable to use.

Those with access to a friendly printer may be able to acquire cheap, or even free, batches of paper. Do take care, however, because much of the printing nowadays is done on coated papers, and these have a surface unsuitable for calligraphy.

When selecting paper for calligraphy, whether it is for practice or for best work, feel the surface of the paper. It should be smooth, but not greasy. Some *cartridge paper* pads seem slightly shiny, and the pen skates over the surface without making good contact. However, if you do have a paper which does not react well with the pen, turn to pages 118 – 119 to see what to do with difficult papers.

The weight of paper

At the point when you feel ready to write out a piece on good paper, take care with your selection and ask for help. Paper comes in a variety of weights and sizes and in three surfaces.

In the past, it was almost impossible to tell the weight of paper as this was related to the size of the sheet. You had to be familiar with the name and exact size of each sheet. The names ranged from *antiquarian* (53 × 31 inches) to *pot* (12·5 × 15·5 inches). Fortunately for paper users, the weight of paper has now been standardised, and is measured in grams per square metre, or *gsm*. A higher number gsm means a heavier weight paper. Photo-copying paper is usually 70 – 80 gsm, good quality letter writing paper, 100 gsm, paper suitable for writing out a piece of calligraphy could be about 150 gsm, and a heavier weight paper, which is almost a card, is 280 – 350 gsm. The paper used in this book is 90 gsm.

Paper manufacture

Paper is made from various sorts of cellulose, mixed to a pulp with water, with chemicals added to fill, bleach, colour and size it and then made into sheets or a roll. *Sizing* seals the paper so that the ink stays on the surface; almost all papers have some size, even the cheapest newsprint. Paper which is not sized is blotting paper.

Cheaper papers, such as newsprint, are made from wood pulp, which has a relatively high acid content, and therefore discolours quite quickly. Newspapers left in the sun will turn light brown almost within the day. Good quality papers for calligraphy are usually made from rag, often 100 per cent cotton or a mixture of this and linen rag. This has a very low acid content, or none at all, and paper will often be described as *acid free*. Although at the beginning you may not be too concerned that your work is on paper that will not discolour over the years, you will be pleased that the ink will not fade or change colour in a relatively short space of time because there is no acid in the paper.

Grain direction

Most papers nowadays are machine made. Once the pulp has been mixed with the chemicals, it is spread out on a conveyor belt

to make a roll of paper. It is sold in rolls, or cut into sheets. The process of pulp moving on to a roller shakes the fibres into one direction – that of the rollers. The direction of these fibres is called the *grain direction*.

Grain direction makes little difference if you are writing out a broadsheet using the whole sheet of paper, but if you are making a book, putting a wash on the paper, or tearing the paper into smaller sheets, grain direction will affect your work. Paper is easier to tear or fold along the grain direction than across it. When making a book, the grain direction should always be vertical, in the same direction as the spine.

It is easy to identify the grain direction. If the paper is quite thick, bend it in both directions. You will find that there is a slight 'give' along the grain direction. For lighter weight papers, moisten a strip about 4 cm wide and 8 cm long along both edges of a corner. The paper will begin to curl along the grain direction.

Moisten the paper at both edges of a corner.

The paper will curl along the grain direction.

Handmade paper

Paper which is handmade does not have grain direction, because the process of making the paper is different. For each sheet, the paper pulp is scooped on to a wire frame. This results in the paper fibres lying in different directions, rather than one way. You do not have to consider grain direction with handmade paper.

Paper surface – Wove and Laid, HP, Not and Rough

The surface of the paper will affect how your letters look. Some papers have a very smooth surface, others show a series of lines. This used to indicate how the paper was made. With handmade paper, the screen, or mould, on which the paper pulp was scooped, could have a very fine mesh of wires. This produced a smooth paper, with no lines showing. The paper was called *wove.* With other papers, the parallel wires which made the mould, were more prominent. The paper pulp was thinner along these lines, called laid lines, which showed on the paper. This paper was called *laid.* The names for these two papers are still used today, but modern manufacturing methods have done away with the need for special paper-making moulds.

Paper can be finished in one of three ways once it has been made. Usually it is passed through heavy rollers, which are heated. The paper is called *hot press* paper, or *HP*, and results in a smooth surface which most calligraphers choose for their work. Photocopying paper, writing paper, paper used for books, cartridge and similar papers are hot press.

Paper which has not passed through hot rollers is called *Not*, and the surface of this paper has a texture to it. Some handmade papers and watercolour papers have this surface. This paper is sometimes called *cold press.*

Paper which is not passed through any rollers, but which dries just as it is, has a rough surface and is called *Rough.* Certain watercolour and handmade papers have this surface. Although you will usually use HP paper, do experiment with not and rough surfaces.

Letters written on hot press paper have smooth outlines and solid strokes

Letters written on **HP** paper

Letters written with the

same pen on Not paper

are less smooth & solid

*Letters written on **Not** paper*

On Rough paper they

are even more broken

Try writing with a thin nib

*Letters written on **Rough** paper*

You may want just one letter or word to have the appearance of being written on a texture, and the rest of the piece to have smoother letters. In this case, write the one word or letter, and then burnish the rest of the paper with an agate burnisher, but put a piece of thin bond or layout paper between the burnisher and the paper, otherwise the surface will look too shiny. Try this out on a scrap of paper first, so that you know how hard you have to burnish.

It is a very good idea to keep your own collection of different papers. Write on a small snippet of each paper the weight of the paper, its surface, the sizes in which it is supplied, where it can be purchased, and what it is like to use. This will then be a permanent reference of papers that you can use.

Keep a record of the papers you have used.

Dealing with difficult papers

There are occasions when you have to use a paper which does not have the ideal surface for calligraphy. You may be asked to write in a book or a client may request a commission on a specific paper. If you can, always try out a few letters on a scrap of the paper first to see how the surface takes the pen. Although Chinese stick ink is the preferred writing medium, it may feather out or bleed on some papers. This is where jet black gouache will be the better choice. If even this does not work well, then there are a number of ways of improving the surface for writing.

Pounce

If the paper seems greasy, you can use *pounce*. This is a powder, usually a mixture of powdered cuttlefish and pumice.

Sprinkle a little on to the surface, and use a piece of cotton wool to rub it in very gently. Brush the surplus off the paper with a large, soft paintbrush, or a soft, mop-headed make-up brush. The pounce can be re-used; keep it in a screw-top or other airtight container.

Gum sandarac

If the ink does not settle well on the surface of the paper, then use *gum sandarac*. This is also a powder, although is sometimes sold as lumps of resin.

The lumps should be ground in a pestle and mortar to a fine powder. Scrub the pestle and mortar carefully with cold water after use, as any gum remaining and allowed to get damp will make a sticky residue, and be very difficult to remove.

Gum sandarac is spread on the surface and rubbed over in a similar way to pounce.

You can also put a small amount of the powder into a 100 cm square of cotton or other fine-woven material. Tie the material up with string and dab the gum sandarac on to the paper through the material. Hold the paper vertically and tap it to remove any surplus.

Gum sandarac acts as a resist to ink or paint. Too much will make the pen strokes separate into two. If this happens, gently rub some of it off with a pad of cotton wool.

Put some gum sandarac onto a square of cotton or fine-woven material.

Tie the material into a bag with string.

Preparation recipe

You can make your own preparation for using on paper and vellum by mixing together 8 parts of ground pumice powder, 4 parts of ground cuttlefish bone and 2 parts of gum sandarac powder. Keep this in a airtight container.

Vellum

Some pieces of calligraphy work very well indeed on vellum. It is a beautiful surface on which to write, and also paint. However, it is a very expensive material to use, and you may prefer to wait until you have a special piece to do before you tackle a skin.

Types of vellum and parchment

Most people use the term *vellum* to cover all types of animal skin. In fact, the word vellum was originally used only for calfskin, and is the term for calfskin used by most professional calligraphers today. There are different types of calfskin, but that prepared for writing on both sides is called *manuscript calfskin vellum*. Others are worth trying once you have got used to this.

Parchment is sheepskin, and although it is usually cheaper than vellum, is not really to be recommended, as it is greasy and difficult to make good, sharp letters. It is also more difficult to rub out on parchment. The records of the Exchequer, called the Pipe Rolls, were usually written on parchment, rather than vellum, because then any alteration and erasure could easily be seen. (They were called Pipe Rolls because the skins of parchment were rolled to form the shape of a pipe.) Mistakes can be rubbed out of vellum often without detection (see pages 141 – 142).

Other animal skins to try are *goatskin* and *kangaroo*.

Choosing a skin

A skin is expensive, many times more than the price of a sheet of handmade paper. A large skin will give you a piece of vellum for a large piece of work, or two smaller pieces, as well as a number of offcuts which can be used for smaller pieces still, scraps which, when mounted, can be used for greetings cards, and finally tiny pieces which can be used to make vellum size, used in gilding. So although it is a large outlay at first, a skin is good value. Of course, it is best to select a skin for yourself, but this is not always possible. I have always found the vellum manufacturers to be very helpful indeed in selecting a suitable skin when I have explained to them the size and what I want the skin for. They will often have skins which are not perfect and are therefore cheaper, and the defect may be in a corner which will be cut off when the skin is used.

Storing skins

Most whole skins of vellum are kept in rolls by the manufacturers. When you receive the skin, it is best to allow it time to flatten. Unroll it carefully and put it flat between two

sheets of clean paper, with a large board or cutting mat on top. If necessary, put a weight on the board (some large books should suffice). At this point you will realise what a strong, tough material vellum is.

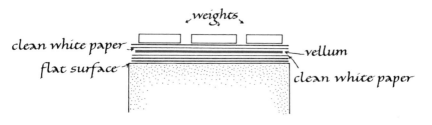

Keep skins and off-cuts of vellum flat. Heat will make it curl, and damp will cause it to cockle (or buckle). It should be stored carefully.

Hair and flesh sides

Unless you are using both sides of the skin, as in a book, it is best to use the hair side only. This is the preferred surface and will give you the best results. It can be a little difficult to identify the two surfaces of vellum. The hair side has more character, is slightly darker in colour, and more marked. It may have some tufts of hair still adhering to the edges. The manufacturers write the size of the skin on the hair side. Conversely, the flesh side is whiter and much smoother, even waxy in appearance, and does *look* like the surface you should be using!

Stretching vellum

Larger pieces of skin should always be stretched. Vellum is a natural material, and will react to the atmosphere by curling in heat and cockling in damp conditions. A large piece of the skin will wrinkle and cockle even in a frame if it is not stretched over a board.

Some scribes prefer to write on the skin first and then stretch it; others, including myself, prefer to stretch the skin first. There are advantages and disadvantages in both procedures. Stretching the skin first means that you will have to deal with a bulky board, and writing at the edges of the piece is more difficult. (I overcome this by taping a piece of paper to an off-cut of the

board to avoid splinters. When writing over to the right hand side, this wood off-cut is pushed against the board so that my hand does not slip off the edge.) However, stretching first does mean that the finished piece will not be spoilt later by water or paste, which is particularly important if there is raised gold on the vellum. On the other hand, if you have a very large piece to write, perhaps using most of the skin, it is much easier to deal with unstretched, although you will then have the water and paste problem at the end.

There are different ways to stretch vellum using modern glues or lacing the vellum across a stretcher. This is the way which I have usually found to be successful.

You will need:

> *plywood*
> *handmade paper and cheaper quality paper*
> *white blotting paper*
> *a small sponge and some water*
> *thick polythene*
> *a board or cutting mat, and weights (these could be large books)*
> *heavy duty wallpaper paste and a decorating paintbrush*
> *scissors, or a knife and metal straightedge*
> *a bone folder (as used in bookbinding)*
> *your piece of vellum*

The *plywood* should be cut to the same size as your finished piece of work and then the edges sanded. The thickness of the wood depends on the size of the finished piece. Small pieces, less than 30 cm square, can be stretched over wood which is 6 – 7 mm thick. Larger pieces will need wood which is 10 – 15 mm thick. Obviously you will need your vellum, but also a piece of good quality, preferably *handmade, paper* which is about 180 – 200 gsm. A piece of museum board (acid-free mounting board, available from picture framers and paper suppliers) will do if you have problems getting the paper. This forms a cushion between the board and vellum, and means that you do not write on a hard surface. It also reflects back the colour and texture of the vellum, so select a good white sheet of paper or board. I stick a *piece of paper* on to the back of the board for neatness, but the quality of this does not matter too much. In addition to this, you will need *white blotting paper*, and thick *polythene* – I use large freezer bags, which may need to be slit open if you are stretching a large piece. Lastly, heavy duty *wallpaper paste* is required. Although this will

stick wallpaper if stored for some time, it is not so effective with vellum.

It is not worth trying to economise when stretching vellum. Many is the time that I have regretted allowing an insufficiently large margin, and have made problems for myself. Using a pencil and set-square, mark on the back of the vellum the length and breadth of your finished work. Add to this the width of the board you are using and at least 4 – 5 cm to take over the back of the board.

This is the procedure:

1 Cut out the vellum with these additional dimensions using scissors or a knife and metal straight edge.

2 Place the vellum with the right side, the hair side, facing downwards, on to a sheet of white blotting paper. You may prefer to place the blotting paper on to a board, rather than your table or desk.

3 Now put another sheet of white blotting paper on top. The blotting paper must cover the whole piece of vellum. For a large piece, you may need more than one sheet.

4 Starting with the thickest part of the vellum, gently sponge water on to the blotting paper. Do this reasonably quickly, as you do not want one area to dry out before you have finished.

5 Cover the blotting paper with thick polythene, and place a board or cutting mat on top. This should all be weighted down with heavy books.

The aim is to get the skin to relax from its stiff, dry state, not to become so wet that it is almost transparent. It will take between ten and twenty minutes for the skin to become properly relaxed, although some tough skins may take longer. You can check on the progress by removing the board and weights and gently rolling back the blotting paper.

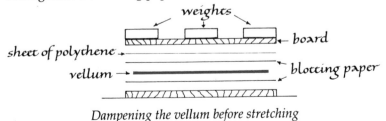

Dampening the vellum before stretching

While you are waiting for the vellum, prepare the board.

6 Cut the piece of handmade paper and the piece of ordinary paper so that they are smaller than the board by about 1 – 2 mm.

7 Attach the handmade paper to the board with a small dab of paper glue in each corner.

8 Turn the board over on to a clean piece of paper, and size the board with the wallpaper paste. Using wallpaper paste means that if the whole thing does go wrong, you can gently soak it off and start again. Brush the wallpaper paste around the edges of the board and on the back in a border about 5 cm wide.

Put the ordinary paper to one side.

When the vellum is ready, remove the board and weights, the polythene and the blotting paper.

9 Gently place the backing board with the paper face downwards on to the vellum.

10 Use your original pencil measurements, although it is likely that, with the damp vellum, these will not be exactly square. Carefully cut out the corners.

11 With the decorating brush and wallpaper paste, paste the vellum that you can see, and the back and sides of the board again.

12 Pull one side of the vellum gently over the backing board and, with a bone folder, make sure that the vellum is pushed square against the board. Press it down firmly.

13 Do this with the opposite side, and then with the top and bottom. Press the corners down with the bone folder.

14 With a knife and metal straightedge, make a diagonal cut across each corner. Gently lift up the corners of vellum with the point of the knife, and remove the triangular pieces which have been cut away. (These can be washed and used for vellum size, see pages 182 – 183.) Smooth down each corner again.

15 Paste over the back of the board and the vellum and stick the sheet of paper which has been cut to size.

16 Remove any paste that you can see with the sponge and water.

17 Leave the board and vellum, face upwards, to dry out naturally. Depending on the weather conditions, it may take a whole day.

Stick the handmade paper to the board with paper glue.

Place the board, face downwards on to the back of the vellum.

Cut away the corners, paste the vellum and board and pull each side over the board.

Make a diagonal cut at each corner, lift the corners and remove the waste vellum. Press down each corner.

Last of all, paste a piece of paper on to the back of the board, and leave it all to dry naturally.

What to do if it goes wrong

The advantage of using wallpaper paste is that, if it does go wrong, you can simply wash off the paste and re-stretch the vellum. Do this if the vellum is very bubbly and uneven. This could be because the vellum itself is uneven; very thick in some places and thin in others. When re-stretching, soak the thicker places more than the thinner ones, if this is the case. In a real emergency, when there is only one area which will not lie flat, if it is unobtrusive, you could try dampening just this area and applying a very low heat from a hairdryer or a domestic iron, on its lowest setting, through a piece of paper. The surface of the vellum will not be quite the same, but if there is no time to re-stretch the piece, then such measures may be necessary.

Preparing vellum

Use a small piece of the vellum cut from the same skin as a test piece. Newly prepared vellum can sometimes be used without any other preparation, but most scribes prefer to prepare the skin for their work.

The *nap* of the skin needs to be raised, the grease removed, and gum sandarac rubbed on the places where there is to be writing. Raising the nap makes the surface of the vellum look a little like velvet, and helps to make the letters sharp and crisp. In the past, scribes raised the nap by scraping it with a knife. It is easier to do this now with sandpaper. I start by rubbing the skin with grade 350 – 400 sandpaper, then sometimes with 500 and followed by 600, which is very fine. You need to experiment with each skin to see how much sanding you have to do to raise the nap. Try it out on the test piece. Care is needed with sanding. Wrap the sandpaper around a wooden block. Start in one corner, and gradually work your way over the whole skin applying the same pressure. Working on one area at a time creates heat, which can cause the skin to cockle. Moving the sandpaper block quickly and carelessly from one area to another may make a crease in unstretched vellum. This is extremely dusty work, so it is best to do this in an outer room, if possible.

A greasy surface is not only difficult to work on, but will result in uneven letters, as the ink will not adhere to the greasy areas. The skin should be rubbed with pounce to remove the grease in the same way as paper is treated (see page 118). After use, brush

the pounce to one side and tip it back into a jar for re-use.

Powdered gum sandarac is applied just before writing, when the lines have been ruled and any outlines for painting marked on the vellum. Dab the bag of sandarac over the area where you are going to write, nowhere else. With a large, soft brush, remove any excess, which again can be re-used. You may like to refer to pages 138 – 140 for details of transferring a piece of work from rough to neat.

A writing board

It is more comfortable to write at length on a board which slopes. The angle of slope also controls the amount of ink which flows from the pen, so the steeper the slope, the slower the ink flow, the more gentle the slope, the greater the ink flow. If you look at historic pictures of scribes writing, most of them are working at a sloping board, and certainly within living memory sloping desks were used in schools. Some students, who have rediscovered sloping boards at calligraphy classes find them so comfortable that they have devised a small sloping board to use at home when doing any writing, not just calligraphy.

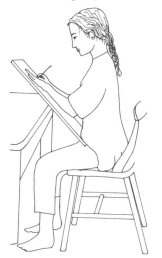

Rest a board in your lap, leaning it against the edge of a table.

Or prop up a large tray with tins or books to make an angle of 45°.

On the previous page note how the calligrapher is sitting in a relaxed position, both feet on the floor and sitting well back in the chair. The pen or quill is held at a steep angle to the board.

It does not matter what you use to make a slope. You can rest a piece of wood or a large tray in your lap, and lean it against the edge of a table. You can prop up a large book with other books, or even tins of beans, on a table and use that. Two pieces of wood can be hinged together, with a wedge device which slopes the upper board to an angle of about 45°. Or you can buy a manufactured board, which, if it has a sliding rule, will save you a great deal of time and bother, but is the most expensive option.

Setting up a board

It is easier to write on a surface which is slightly cushioned rather than on a hard one, so set up your board to give you the best writing conditions. With masking tape, attach to your board a pad made up of some sheets of large paper, which have been ironed flat if they were folded or creased, covered by a sheet of white paper. The top sheet of white paper is important because it will show through the paper you are using, and allow you to see your letters clearly. Some scribes prefer a softer cushion, and tape two or three sheets of white blotting paper to their boards instead.

Sit comfortably on the chair you will be using, and put your board at a slope of 45°. With a pencil in your hand, move your arm around to try out different heights for writing until you find the one which is the most comfortable. (The height will vary according to different people's preference and individual height.) Mark a line with the pencil at this height.

Fold a long piece of paper in half lengthwise and put pieces of masking tape at each end. With the fold at the top, attach one end of this paper to your board about 2 – 3 cm *below* your pencil line. Now pull the folded paper very gently, so that it is taut, across your board, and stick down the other end. The paper that you are working on will be protected by this guard sheet. Your working paper slides behind the guard and is moved from side to side and up and down while you are working, so that *your hand stays at the most comfortable level.* By having the guard sheet taut, it also holds your working paper in place, and this should not then slide

behind the guard sheet just when you have finished a line and the ink is still wet!

pad of paper with white paper on top

paper

writing level

guard sheet

Set up your board like this. (Left-handers should refer to their special section at the end of this chapter.)

If the paper you are using is long, you may crease the bottom section by leaning against the board. To prevent this, make a long cut in a piece of plastic drainpipe or cardboard tube, and slide this over the bottom edge of your board. (It may need pushing on quite hard.) The sheet of paper will roll over the drainpipe and not crease the paper.

cardboard tube or length of drainpipe

Slide a length of plastic drainpipe or a cardboard tube over the bottom edge of your board to prevent long pieces of paper from creasing.

Other tools and materials

Pens, ink and paper are essential for the craft, however, other tools and equipment will make life easier.

Pencils

You will need *pencils* to draw lines for your letters. Those which have a harder point, such as 2H – 4H will not smudge as easily as softer points. They also keep their sharp point longer. When drawing lines, small errors in ruling the width make a noticeable difference to the letterforms. Sharpen your pencils with a knife to a good point, and keep them sharp. Dull points will not produce accurate work.

Keep the points of your pencils sharp for careful, accurate work.

When drawing lines, hold your pencil at the same angle along the ruler or T-square. It is surprising how much difference changing the angle makes to the position of the lines. Try this out for yourself. Careful ruling is particularly important when using smaller nibs, but it is a good habit to always draw accurate lines. After a while your eye will detect even small changes in the width of lines quite easily.

Ruler or T-square

You need a *ruler* or *T-square* for drawing lines to show the width of letters. A long ruler, such as 50 cm, will save you time in that you will not need to move it across the paper. It may be best to choose a ruler which also has a metal edge for cutting. A T-square can be pushed firmly to the side of the board and will ensure that your lines are parallel. A *set-square* is a useful addition or replacement for a ruler. The set-square will ensure that your lines are at 90° to the edge of the paper. Some set-squares are now available with a metal cutting edge.

Knife and scissors

A sharp craft *knife* and *scissors* are also needed for cutting paper. It is best to fold paper and then slit it with a knife, or to cut it accurately with a knife with a metal straightedge on a cutting mat. Scissors can be used for rough work, to cut things quickly, for cutting shapes and to cut masking tape.

Protractor

Marking the angle on your paper with a simple school-type *protractor* will allow you to ensure that your pen nib is held at the correct angle for each hand. It may take some time for you to get used to the hand position for the various angles of the different scripts. Drawing the correct angle at the top of your paper, and frequently matching your nib to this, will help to re-inforce the position. When starting Italic, or a sloping hand, it is sometimes difficult to maintain a constant slope. Drawing parallel lines at 6° for Italic across your paper will help you to be consistent.

Mark a small dot along one line on your piece of paper.

Place the protractor so that the cross point of the horizontal and vertical lines are on this dot, and that the horizontal line is straight. Mark on the correct angle with another dot.

Now join up the two dots. This line shows the correct angle.

Masking tape

A roll of *masking tape* is preferred to clear adhesive tape, as it does not leave a sticky residue behind. Work can also be re-positioned easily with masking tape. It holds pens and pencils together for double pencil work.

Glue

You will need a tube of *paper glue,* or a small pot of *rubber solution gum* to stick your work together, and for pasting up rough copies.

Paintbrushes

Children's cheap *paintbrushes* are useful not only for mixing gouache and watercolour, but also for feeding ink into the pen. It is best to save good brushes for best work, rather than ruining them by scraping around a paint palette, or dipping in black ink, which is very difficult to wash out of a brush.

Additional equipment

As you progress in calligraphy, you will no doubt collect together tools and equipment which you find helpful. Some of my students use empty, washed *polystyrene meat* or *vegetable trays* from a supermarket to hold their ink pot, with notches cut in the sides which grip spare pens and brushes while they work. Others have used *egg-boxes* for the same purpose.

Empty camera *film containers* can also hold spare nibs, inks and mixed paints.

Those who have progressed to calligraphy from cake decorating or doll making find the *small brushes, palettes* and *see-through containers* ideal for calligraphy.

Tiny porcelain *crucibles* are excellent for calligraphers' use. Paint palettes for artists are not really ideal for calligraphy, although they are almost always used. They are shallow, and the paint dries quickly. Calligraphers need a small deep container, such as the crucible, so that the paint stays wet and usable for as long as possible. However, obtaining crucibles is not easy, and access to a specialist supplier is needed.

After all this, you may need a *box* or *container* in which to keep your equipment. Open containers with a handle and compartments, used for cleaning materials or tools may suffice, or a box designed for people keen on fishing may be a good choice. This has a number of compartments, and two or three separate trays, and is much cheaper than a specialist box sold in art shops.

You will at some point need a *portfolio* or somewhere to store your work. There are two cheap possibilities here. You can use the cardboard backing from two large pads of paper taped together to make a perfectly serviceable portfolio. The boards could be covered with attractive paper, if you wish. Alternatively, you can use a metre length of plastic drainpipe; that which is about 12 cm in diameter is the most suitable. Tape a circle of strong paper or card across one end, and always make sure that you carry the tube with this end at the bottom. You could fix another circle of card with masking tape across the other end if you think your work will fall out, and could also attach a carrying strap or handle.

A *light box* is certainly not essential for those just beginning the craft, but is a very useful item later on if you are pasting up work for photocopying and reproduction, or want to easily transfer line markings from one sheet to another. The light box allows you to see through paper and trace.

There are expensive light boxes which you can buy in art or graphic equipment shops.

I am very grateful to one of Rosemary Sassoon's students in Australia for suggesting this ingenious light box.

Try this idea first. Using a box of suitable size from the supermarket, remove the flaps from the top and cut the two opposite sides at an angle of about 45°. Carefully place a sheet of perspex or thick plate glass on the box, and put a torch inside the box. When you want to use the light box, switch on the torch, and it will give you sufficient light to see your work.

If you wish to be more sophisticated, you could arrange for a proper light source, using a low watt bulb and an electric flex. Do allow for the proper safety standards, however, and do not leave a heated bulb resting against the cardboard.

Left-handed calligraphy

There is no reason at all why you should not take up calligraphy if you are left-handed. You may have to change your usual penhold slightly, because you do need to be able to see the lettershapes you are making. This is not always possible if you hold your pen in such a way that it masks your writing.

You will also have to decide how you will sit and hold your arm. Some left-handers twist their wrist to the left to such an extent that they can still use square cut nibs designed for right-handers and maintain the correct angle. The wrist joint must be fairly flexible and the strain on the joint is quite considerable. It is not a position to be recommended, but it has worked successfully for some very eminent calligraphers.

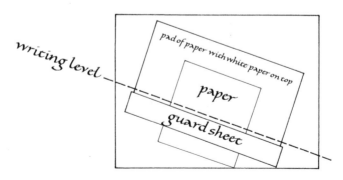

Left-handers may prefer to set their boards up in this way, and use left oblique nibs.

Others find it easier to set up their boards in a different way to right handers, which enables them to obtain a much more relaxed posture and arm position, and, by using left oblique nibs, they can also make sure that their letters have the correct pen angle.

The same method applies for right-handers and left-handers when positioning the guard sheet. Sit on the chair you will usually use, with your board set up at an angle of about 45°, and try writing with your hand in different positions and heights. When you feel at your most comfortable, make a pencil line, and attach the guard sheet at about 2 – 3 cm below this, holding it taut as you do so.

Some left-handed calligraphers prefer to stand whilst they are working, and have their paper at an almost vertical angle. Try any position and hand/wrist angle until it suits you and you are most comfortable, remembering how important it is to relax and not to tense up.

When cutting pens and nibs for yourself, remember to cut left oblique if this angle suits you best. You can cut home-made pens at a much more oblique angle, and see if this is more comfortable.

Cut your own pens with a left oblique angle. You may prefer to start calligraphy by making and using your own pens, cutting them at an angle which you find the most comfortable to use.

If you have an angled lamp which you can use at home, set this up on your left hand side so that your hand does not make a shadow, and that you can see your work clearly.

Some alphabets may be more suited to left handers. It could be better to start calligraphy with *Uncials* (see page 33) as the nib is almost flat, or held at a shallow angle. Similarly, *Versals,* (see pages 72 – 73) where the nib is held at 90° and 0° is as challenging for the left-hander as it is for right-handers.

5 · Techniques

Layouts

There are often different ways to set out and present a piece of work. Although the words may seem to need a rather formal treatment at first, it is worthwhile experimenting to see if a slightly different arrangement lends itself to a better interpretation of the text. Of course, if this is work for a commission, then the client's requirements will need to be taken into account as well.

Try laying your work out in different positions on the paper.

When starting to work on a text, write it out fairly quickly at first, possibly in pencil or using a calligraphy felt pen or fountain pen. This will give you some idea of how the lines in the text fall. Always pay attention to the *sense* of what you are writing, and try not to split phrases if you are writing prose. If you are writing out a poem, then the poet's lines should be your guide.

Look again at what you have written. Perhaps one word or line needs emphasis, or possibly some sections should be larger or smaller. Try these out in different sized nibs. Introduce colour at an early stage in your work if you are not working completely in black and white.

You do not need to write out the whole piece each time you make a change. Those lines or areas which you feel are satisfactory can be left, and only the changes re-written. Using rubber solution gum (which means that you can move the paper around for about ten minutes), or small strips of masking tape, or an aerosol glue which allows repositioning, attach the pieces of lettering to a larger sheet. Try out the lines in different places on the sheet and at varying heights.

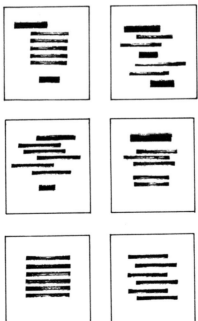

Different ways of presenting the same text.

To get the best idea of how your work looks, attach the paper to the wall with small pieces of masking tape, or pin it to a noticeboard, and stand at least two metres away. It is difficult to assess your work if you view it when it is horizontal, as you will not get the true perspective. Even at this early stage think about the size of the piece and how wide the margins will eventually be.

Sometimes you will need to leave your work for a couple of days, or even weeks, until you are satisfied that the balance is how you want it to be. The luxury of time is rarely possible with commissioned work, however, when there is usually some degree of urgency in its completion.

Transferring rough work to a best copy

When you are happy with what you have done, you will need to transfer the markings on your rough piece as guidelines for your best work. Measure the width and length of your rough; this will indicate to you how large a sheet of paper you will need. Take margins into account. When starting out it is very tempting to have very small margins especially on a more expensive paper. Calligraphy needs space around it to be appreciated properly, and it is a false economy to make the margins too small.

The usual margins for a broadsheet (a piece on one sheet of paper, as opposed to a folded sheet, such as a book page) are shown as units. The units can be millimetres, centimetres, fractions of inches or inches.

There are no hard and fast rules for margins, and you may choose very different margins for your work. It is worth being adventurous.

With a hard pencil (2H or harder), carefully mark a central line down your paper, using a ruler, T-square or set square. Draw the line as faintly as you can. Place your rough on the paper. Try out a number of different positions. A more formal piece will probably look best with conventional margins. Other pieces may draw the eye by being in a more unusual position.

Position the rough paste-up on the piece of best paper to assess the margins you need to allow.

Mark on the left hand side of the paper the point where the piece starts. If the lines are regular, you can use two sets of dividers to mark out the width of the lines and the spaces between them. You may prefer to mark the lines on a strip of paper and transfer these markings to your neat paper.

Draw very faint vertical lines on your paper to mark the left and right margins or limits of your work. You do not want guidelines going right across your paper from one edge to the next. Even though they are in pencil, these lines are not always easy to remove and may spoil the effect of your work.

Using a set-square, T-square, a sliding parallel rule, or a long ruler, draw out lines from the left margin of the finished piece to the right. If the paper has a very soft surface you may prefer to

actually measure out each line, so that the pencil markings are only where you are to write. Alternatively, you may like to make a mask for your work (see pages 143 – 145).

Do not draw lines, even in pencil, all over a sheet of soft-surfaced paper from one edge to the other. Draw lines only where you are to write.

Avoiding errors

It is surprisingly easy to make mistakes in calligraphy. You are concentrating not only on each individual letterform, but also on the spacing and the position of the letters. With such intense concentration, simple spelling errors often occur, even with words or names which are the most familiar. If you have your rough copy propped on your board, or on the table beside your board, making errors is not difficult!

A good solution to this problem is to make a photocopy of your rough work. Draw on the centre line and then cut the photocopy into its separate lines. Number each line in a bold and contrasting colour. With two tiny pieces of masking tape, attach each line just above where you are to write, using the centre line as your guide. The starting and ending position of each line is clearly shown on your rough, so is the spelling of each word, and even the spacing of letters and words. By having this indicated so

close to where you are to write, you will have to be very perverse indeed to make a mistake! Numbering each line should also mean that you do not write one line twice, or write the lines in the wrong order. You will have to wait after writing each line until the ink has dried before you attach the next strip to your paper, but this is a small price to pay for accurate work. Many would prefer waiting a short while than having to rewrite the whole piece because of a mistake in the last line.

ÇOHE WERE BUT THE WIHTER,
 COME WERE BUT THE SPRIHC,
I WOULD ÇO TO A COVERT
 WHERE THE BIRDS SIHC;

WISIHÇETH A THRUSH ?ORH
 SIHÇETH A T

Try sticking a photocopy of the line you have to write with masking tape just above where you are going to write it. This helps avoid errors.

Removing mistakes

If you do make a mistake, all is not lost. You can often remove mistakes from good quality paper, although it does take time, and you need to assess whether it will be quicker to start the piece again.

Assuming that you are using non-waterproof ink or paint, *as soon as* you realise your error, blot any wet paint straight away to remove what you can. Sometimes, however, you may not realise your error until the end of the piece, when the ink is dry. In this instance, you will have to try to get as much paint out as you can.

You will need a clean, fine paintbrush, a jar of clean water, and clean, white tissues or kitchen towel. Wet the paintbrush and gently paint over the wrong letter or word. Blot this immediately

with the tissues or kitchen towel, *but do not rub the paper*. Repeat this process as many times as necessary until no more colour comes out of the paper onto a clean piece of tissue. Leave the paper to dry. It may take a couple of hours, but it is important that it is *completely* dry. With an ink eraser (typewriter erasers in the shape of a pencil are best, because they can be sharpened to a blunt point), gently rub at the error. Take it slowly and do not press hard, or try to hasten the process.

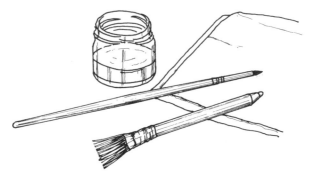

Remove errors with clean water and a paintbrush, a kitchen towel and an ink eraser.

When the mistake has been removed completely, place a piece of thin paper, such as layout paper, over the error, and gently rub with the back of your fingernail, or a burnisher. This will flatten the paper so that the correct letter or word can be written in. Try just one letter first. If you have used Chinese or other ink for the piece, you may prefer to change to dilute gouache for the correction as this does not bleed so easily, as long as this change is not obvious. It is unlikely that you will need to re-size the paper, as most manufactured paper is sized in the paper-making process. However, if the ink or paint does start to bleed into the paper, use an aerosol fixative spray. Cut a rectangle the size of the word or letter in a piece of photocopying or layout paper. Place this over where you have removed the mistake. Spray the paper very carefully with matte spray fix. This should seal the paper so that you can write without any further problems.

Some scribes take out their mistakes using a sharp scalpel and making a shallow scoop in the paper. This is a very skilled process and does require practice.

Rubbing out lines

When you have finished writing you may want to erase the lines. Do this with great care. Wait until you are sure that the ink is completely dry, and with a very soft eraser, perhaps a putty eraser, gently rub out each line, taking especial care near your lettering, particularly if the paper is soft. Do not make the mistake of blowing the rubbings away, or smoothing them away with your hand. Many pieces of work have been ruined by the moisture in breath or on the hand. Instead use a large soft paintbrush or a mop-headed make-up brush to remove the rubbings.

Using coloured and textured paper

One way which will make a difference straight away to how your work looks is to use a coloured or textured paper. Papers are available in a range of colours, which extend from pastels to dark shades. With a dark coloured paper, you may find it better to use a lighter colour gouache paint. Try this out on a scrap of paper first. You will need to mix the paint thicker than usual to achieve evenly written letters, otherwise they may look a little patchy. If you decide to use white paint, it often helps to mix a tiny amount of another colour to achieve a sufficiently dense mix. The smallest amount of grey or blue will make very little obvious change to the colour but will improve the texture of the paint. Add a tiny speck of warmer or cooler colours to white to co-ordinate with the shade of paper.

Making a mask for your work

It is not always easy to see the guidelines for writing when using dark paper. If possible, position an angled lamp so that the light shines across your work. You may need to bend your head a little, too. When the piece is finished, guidelines extending beyond the writing is often all you see! There are ways of overcoming this. Having no lines drawn as guides at all is one way of resolving this problem. This makes for a very free, and often lively layout and letters, but may not be the effect you want.

Perhaps the simplest is to make a mask for your piece, which is not as difficult as it seems.

You will already have made a rough paste-up of the piece, so that you know where each line should be placed. Take a photocopy of this. If it is a large piece then take a couple of photocopies which can then be pasted together. Lay the photocopy, pasted up if necessary, on a cutting mat or a couple of layers of cardboard. With a sharp knife cut out the photocopy of your work, leaving the outside in one piece. The outside is your mask, but do not throw away the inside photocopy of your work, this can be used, too, as a guide for your work (see pages 140 – 141). With a pencil or set of dividers, mark on the mask the measurements and spacings for the guidelines.

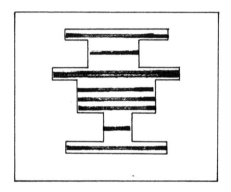

You can make a mask easily by photocopying your rough. Cut out the area of written lines, leaving the mask in one piece. The red line is where this piece should be cut.

Position the mask carefully on your paper and attach it with small pieces of masking tape. You can now draw guidelines, using the measurements marked by your dividers, which will extend from the mask on one side, across the paper, to the mask on the other. There will be no lines on the paper which extend beyond where you will be actually writing because of the effect of the mask.

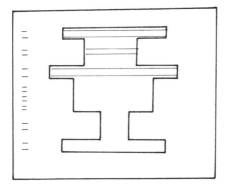

Attach the mask to your best paper. The pencil marks for guidelines will appear on your paper only where you will be writing.

Before you try to rub out pencil lines on dark paper, experiment on a test piece. Sometimes the smudge marks left by the eraser look far worse than leaving the lines on the piece.

Colouring papers

Even the greatest range of coloured paper may not match the particular shade or effect you wish. In this case, you may want to colour the paper yourself. You can do this in different ways.

Painting paper

To achieve an all-over shade, or even a texture or variety of colours, you can paint the paper and write over that. Unless the paper is handmade (where the grain direction does not matter), or the paper is very thick (about 280 gsm or more) you will need to stretch the paper. If the paper is not stretched it will cockle and be uneven and very difficult to write on. Allow for a good margin on the paper. You will have to cut off about 1 – 2 cm all around the paper after it has been stretched.

To stretch paper you will need:

> *a piece of paper, large enough for your work and a margin of 2 cm all round which will be cut off*
> *a board large enough for the sheet of paper to lie on,*

with an additional margin of 3 – 4 cm
brown gummed sealing tape about 4 – 5cm wide

Start a new roll of brown gummed sealing tape from the middle. The roll handles better this way.

Masking tape or clear adhesive tape is no use for stretching paper because it will not stick to wet paper. The board can be of any material, although a wooden board does hold the paper firmly in position. For demonstrating, I usually use a formica chopping board, which works perfectly well with paper A4 size or less, although it may be a little slippery for larger sheets of paper.

Measure out four pieces of brown gummed sealing tape to go around the sheet of paper. Put the two pieces for the sides to one side, and the two pieces for the top and bottom at the top of the board. This is so that you know which is which, and they are to hand.

The paper needs to be dampened. You can do this by sponging carefully over the surface of the paper with clean water and a sponge, or by simply putting the paper in shallow water in a bath (if it is a large sheet of paper) or the kitchen sink (if it is a smaller sheet). The paper needs to be damp to relax the fibres, but not sopping wet. Allow any excess water to drain away, and then place the paper on the board.

Attach the dampened paper to the board with gummed paper strips.

Dampen one of the gummed strips and stick it to one side of the paper. Repeat this with the other side strip of gummed paper, but before sticking it down, lift the paper carefully and *very slightly* pull the paper so that it is taut. There needs to be only a *little* tension in the paper. Now dampen the gummed strip for the top of the paper, and stick it to the paper and board. Then repeat this with the bottom strip.

The paper may well look bumpy, as the water stretches the fibres in the paper. As the paper dries, however, the gummed strip along all sides will hold the paper tightly and it should dry completely flat. If there are any problems, the paper can be cut away from the board and the process repeated. Until you are familiar with the technique, you may wish to do this with small, inexpensive papers, so that you do not have any concerns when stretching larger sheets of expensive papers.

Do *not* detach the paper from the board. The point of stretching the paper is so you can add washes to it without fear of it cockling and becoming unmanageable. Washes are added whilst the paper is stretched. Only when it is completely dry and you have the effect you want do you then cut it away from the board.

Putting a wash on paper

To add washes to the paper, first mix the chosen shade of watercolour. It is better to make a number of thin coats rather than mixing too strong a colour at the beginning. Tilt the board very slightly; propping it on a paperback book at the top edge will give sufficient slope. It is best to use a large watercolour wash brush. These are wide brushes, with a head usually 2·5 – 3 cm wide and about 3 cm long, with a straight edge. However, you can also use a paintbrush for home decorating or a pad of sponge.

With watery paint and the large wash brush, or whatever you have chosen to use, start at the top of the paper, and make a series of horizontal strokes which go from one edge to the other. Try to have enough paint so that you do not have to stop in the middle of a line. Work quite quickly so that the paint does not dry, if it does you will have a line across your work.

Start at the top, and with a wide brush apply the paint from one side of the paper to the other.

Other wash effects

You may wish to add *other colours* to your wash. Experiment to achieve the effect you want. Add other colours before your first wash has dried. Or add colour when it is dry – the effect will be different. Drop colours or even plain water into *wet colour*. The new colour will bleed into the first coat, and this is interesting. Try *taking off some of the paint* by blotting it with a tissue or kitchen towel. This can give an unusual texture. The resulting effect when *salt* is dropped on to a wet wash could be the one you want to achieve. Try also putting a piece of *clingfilm* or *thin plastic foodwrap* on to a wet wash. Slightly crease the film, and leave it on the paper until the paint is dry.

Dropping clean water into a wash. Adding another colour to a wash.

Adding salt to a wash, *and laying a piece of clingfilm on a wash.*

There are various ways of achieving slightly different effects with a wash, and experimenting yourself is often the best method of finding out exactly what you want. Once the wash is dry you can add texture to it in a number of ways. The textured effect can be made on the paper without a wash. You can make a random pattern with a *dry sponge* dipped into paint. A similar effect is made with a crumpled piece of *kitchen towel*, although the pattern is more marked with this.

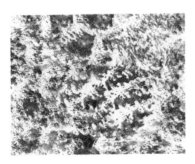 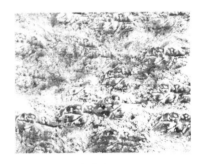

Making patterns with a dry sponge *or a crumpled tissue.*

Before you write

When the paint is completely dry the paper can be cut from the board, and the strips of brown gummed tape trimmed away. The paper is almost ready for your calligraphy. Often, you do not get good, sharp letters when writing on a wash in paint or ink. One layer of paint bleeds into the other. To counteract this, rub on some gum sandarac powder where you are to write. Occasionally

the powder makes the wash a little lighter, especially if it is particularly dark. Try gum sandarac on a corner or a test piece. If it is not effective, spray the paper with fixative spray. You can buy cans of this in art shops, but do make sure that you have fixative with a *matte,* rather than gloss, finish. Once the fixative is dry, there should be no problem about writing on a wash or layer of colour.

Using coloured pencils or pastels

You do not need to stretch paper if you add colour in another way. Simply shading with a coloured pencil or pastels is effective. So also is rubbing on colour from pastels, which have been made into a powder with a sharp knife. Pastels *(not* oil pastels, which are greasy!) are available from art shops, and can be made into a powder very easily by shaving the edge with the blade of a knife. This can then be dabbed on to the paper with a small pad made from cotton wool and rubbed in carefully. Colour can either be added all over the paper, or randomly, or in a pattern. More than one colour can be added for a mottled effect.

Feeding colour into the pen

Colour can be added to letters and writing in other ways. If you feed a limited range of colours into your nib as you write, the effect in the letters will be of random colour. This technique does need some practice to perfect. It is best not to leave the randomness of colour totally to what comes out of the pen, otherwise there may be blocks of colour in one part of your piece, and more random colour in other sections. Look at the letters as you are writing, you may need to add a darker or lighter colour as you write each letter.

Keep washing your nib and reservoir, otherwise the colours will start fresh, but soon become muddy. Do not rely on the nib alone to mix the colours. It is better to have five or six subtle shades of colour to use in your palette, rather than three main colours which may make the contrast too marked. See page 151.

Adding colour to writing in water

A more adventurous way of mixing colour in calligraphy is to write in ordinary water, perhaps with the tiniest amount of

watercolour added, just so that you can see what you have written. Before the water has dried, drop dilute watercolour into the letters. The colour will bleed along the letter. If the letters are joined in any way, or overlapping, the colour will spread from letter to letter and mix to make very interesting shapes in the letters. This method is very difficult to control, and it is probably better to reserve this for shorter pieces. Then you can write out four or five versions and choose the best one.

for softness she &

Letters written in water with colour added before the water has dried.

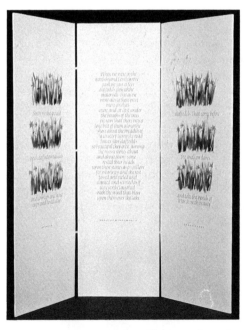

This Daffodils triptych was a commission. The central panel was written by feeding shades of green and yellow gouache into a no. 6 William Mitchell nib. The side panels have shorter quotations about daffodils, written in a similar way, separated by clumps of daffodils, painted in watercolour.

(Reproduced by kind permission of Susan Suchopar)

Blotting out colour

You can achieve a very interesting effect with watercolour paint by designing a piece where the letters are drawn and then painted. Before the paint has dried, flood the colour with clean water, then blot out the watery paint. This can be done with the corner of a tissue or kitchen towel, but try also using a medium-size brush.

Blotting out the paint from letters achieves an interesting effect.

Resists

Sometimes you will want to add colour, but have some or all of the lettering remaining the same colour as the paper. You can do this by masking areas or letters before adding a wash. This can be done in a number of ways.

Masking tape

The easiest method of using a resist is to use strips of *masking tape*. These can be cut or trimmed to shape, or used to make rectangular letters. The glue used for masking tape allows the tape to be lifted from paper. Because of this, the paint may bleed very slightly under the strips of tape, and will not give a completely clean line.

Resist letter made with masking tape, covered with a wash.

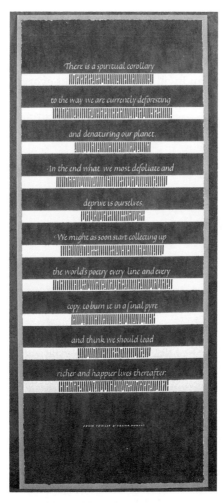

Masking tape was used as a resist in this panel. Horizontal strips were laid on Saunders Waterford paper, which had been stretched. Layers of watercolour were applied with a brush and a natural sponge. When it was dry, the paper was cut from the board. The interesting black letters were developed on a day course with children. We were seeing if we could make an alphabet which was essentially thick vertical lines and thin horizontal ones. The 'translation' was written in a lively Italic in white gouache after gum sandarac had been rubbed on. The effect reflects the text – fire destroying vegetation and isolated stands of blackened trees.

(Reproduced by kind permission of C. Hinks)

Wax candle

A *wax candle* makes a good and unusual resist. It will give a textured effect on the paper. The candle can be cut to a wedge-shape, so that you can write letters which have thicks and thins. The wax is soft, and will need to be re-cut every few letters. Once the letters have been written, brush on a wash with watery paint.

Wax candle as a resist.

Masking fluid

For sharper letters you can write with *masking fluid*. This is a rubber solution which can be bought from art shops. It is available in white or yellow. The yellow is better as it can then be seen on white paper. Sometimes the masking fluid is rather thick, and for writing it is better to dilute it very slightly. Adding a few drops of water to the solution will probably be sufficient. If it is made too dilute it is not effective and the paint from the wash bleeds through. Although the paper does not have to be stretched *before* using masking fluid, I would recommend that it is. The masking fluid is such that by brushing against it very slightly the letters will peel off, and it is very easy to brush across lettering during paper stretching.

Dilute masking fluid is fed into the pen in the same way as ink. You will probably need to wipe the pen quite frequently, as the fluid does tend to dry quickly, and not give sharp letters. Use an old brush to mix the masking fluid, and to feed the ink as the fluid is very gummy and ruins good brushes. When you have finished, wash out the brush, nib and reservoir straight away in cold water. Allow the masking fluid to dry before applying the wash. When the wash is completely dry, then the masking fluid

can be removed by rubbing with a very soft eraser, or even with a finger – but do take care. You can add more letters with masking fluid and make a series of washes in different colours for an interesting effect.

*The word **Calligraphy** was written with masking fluid. A wash was brushed on and left to dry completely. Finally the masking fluid was removed by rubbing gently with a soft eraser, revealing the letters beneath.*

White gouache
Some people find handling masking fluid rather difficult, and for them *white gouache* may be the better choice. This is a method devised by John Woodcock. For this you will need good quality handmade paper at least 200 gsm in weight. Write with white gouache which has been mixed to quite a thick consistency, using a *very* light touch. The pen must not cut the surface of the paper. You could try writing with a quill, or even with a broad-edge (one-stroke) brush.

When the gouache is completely dry, brush on a wash of *waterproof* ink. And when this is completely dry, the white gouache can be washed off the paper. It is best to leave the paper to soak in a large container, which, depending on the size of your

paper, could be the kitchen sink or even the bath. It may take some hours for the gouache to soak away, but do not be tempted to hasten the process by picking at it.

Other letters can be written on top of the waterproof ink wash, and new washes made in the same or different colours. There are many possibilities.

Write the letters in white gouache.

Lay a wash of waterproof ink on top of the letters, allow this to dry.

Soak the paper in a kitchen sink or the bath to remove the gouache.

Bleach

Another method which has a similar effect to resists is to use *household bleach*. Be warned that brushes, nibs and reservoirs do

not last long if you use bleach, but it may create the effect you want. Dilute the bleach with water. It is difficult to be precise here because it depends on the strength of the bleach and what it is having to bleach, and so it is best to experiment.

To preserve your pens and brushes why not use bleach with tools which are disposable – bamboo or balsa wood pens, for example, which can be recut or discarded?

Letters written with bleach on a wash of fountain pen ink.

Letter rubbings

So often we regard calligraphy, beautiful lettering, as letters which are made only with a pen, or perhaps a brush. This limits the many possibilities of using a whole variety of other techniques and tools to make good and beautiful letters. Here are some ideas for making letters without pens or brushes.

There is a number of ways that you can use letters which have been cut from card. You do not need any special card; cereal packets, grocery cartons, the outer packaging card or inner stiffening card from shirts or packets of tights are all perfectly suitable. If it works in your design, and is the right size, you could even cut out the letters which are printed on the packet, rather than designing your own – but this is not really to be recommended, as it is not very inventive or original!

Design a letter, a monogram or letters to make a word. It could be simply an initial letter for a birthday card, two initial

letters for an anniversary card, or a word for a heading on a piece of work. The letters can be drawn letters, brush letters, or written with two pencils.

Either design the letters on the card itself or transfer the design to the card. You could trace the letters, or place your design on the card and go round the letters pressing hard with a pencil, making an indentation. Put the cardboard on to a cutting mat or layers of old cardboard and then with a very sharp knife, cut round the letters. Take care with the counters, or insides, of any letters.

Design your letters. These were first written with double pencils the thinnest parts then made a little thicker.

Cut them out of card, and place the counters carefully.

To make letter rubbings stick the letters on to another piece of card with paper glue or rubber solution gum. Place the counters carefully in the letters. Put a piece of paper on top of the letters, and gently rub over the letters with a pencil, coloured pencils, pastel or wax crayons.

Rub over the design with a pencil, pastel, wax crayon or coloured pencils.

You could also make a slightly different rubbing with the card from which the letters were cut. Stick this card onto another piece of card, place the paper carefully and make the rubbing.

A letter rubbing of the same design, but using the card from which the letters were cut. Notice that the shading is slightly different.

It can be very effective to make repeat rubbings of the letters or word you have designed, possibly in different shades of one colour, or even in different colours.

Embossing

You can make embossed or incised letters in a similar way. Make a design as before, perhaps even the same design if you are pleased with it. Transfer the design to card from a cereal packet. Cut the letters out, but to make embossed letters you use *the card from which the letters were cut.*

Stick this card *back-to-front* onto another piece of card, making sure that the counters are placed carefully. Embossing is best done from the *back* of the paper. This means that any slips or errors do not show on the front. That is why the letters are stuck on back-to-front.

Place a piece of paper over your letter design. You can emboss with quite thick paper, but perhaps it is best to start with paper which is fairly lightweight, such as photocopying paper. The best tool to use for embossing is an agate burnisher, but there are many other ordinary objects which can be used to press the paper around the letters. The rounded end of a paintbrush makes a good embossing tool, so does the end of a teaspoon, the handle of a metal knife, the corner of a plastic ruler or set square, boxwood or plastic tools used in pottery or even a fingernail. With some of these tools, you will have to be careful not to push the paper too hard, otherwise it will tear. The paper needs to be eased around the cut-out card.

You emboss letters using the card from which the design has been cut. Stick this back to front on to another card, placing the counters carefully. Emboss with a burnisher or similar tool.

Of course, letters are not the only things which can be cut out of card and embossed. Any shapes can be cut out, such as a star, or

Christmas tree, which can be used on cards combined with your lettering. You could cut out your designed monogram and emboss a set of headed notepaper – or do it for a friend as a present. Expensive printers' metal plates, or even cutting shapes out of lino are not necessary; all you need is some cereal packet and a sharp knife!

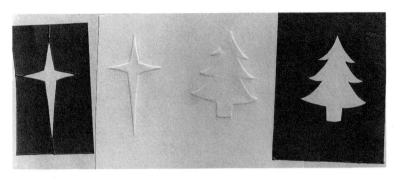

You can emboss any shapes, not just letters.

Indented letters

To make indented letters, letters which go in rather than stand proud, *use the letters which you have cut out*. Paste these onto card, again *back-to-front* and take care to position the counters properly. As before, it is not sensible to place the letters the right way round and press in from the front, as all the marks and any slips will be obvious. Place the paper over the cut-out letters and use the burnisher or other tool as before.

Indented letters are pressed into the paper.

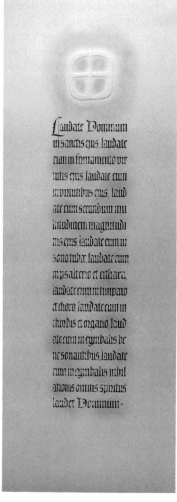

This panel combines Black Letter and embossing. Black Letter works best where the text, as well as the lettering, is regular and even. The Latin version of Psalm 150 was chosen because it was easier to break words at the ends of lines. I used a wide metal nib and a very light touch, so that the pen hardly touched the paper. This gave the lettering a broken look. The shape of a cross was designed and cut out of two layers of cereal packet which were stuck together. The shape was then embossed on to the paper, Rives BFK. Finally, powder was made by scraping a grey and green pastel, and this was rubbed on to the paper with cotton wool.

Interesting designs can be made by using both the cut out letters to make indented shapes, and the card from which the letters were cut, to make embossed shapes. These can be placed side by side to make mirror images.

Embossed and indented letters.

Rubber stamps

Making and using rubber stamps is fun. They can decorate your own stationery, personalise your papers or books, and, because they are so cheap and easy to make, you can make them for friends or special events.

All you need is an ordinary pencil eraser and a sharp craft knife. The sort of erasers from stationers which come in packs, or are sold individually are ideal. You will also need a stamp pad, but you can make one of these yourself.

Draw a letter, or a monogram or any design. You could look at examples of decorated letters to get some ideas, although it may be better to choose a simple design to start with. Make sure that your drawing fits on to the eraser you are using. To make your design smaller, you could use the reduction facility on a photocopier to save time.

Trace round the outline, and transfer this tracing to the eraser. The drawing on the eraser should be *back-to-front*. With the sharp point of the knife, go round the outline of your design very carefully. Do not use the knife at such an angle that it cuts under the design and makes the sides weak. Some people find it easier to use the point of a needle, perhaps pushed into a cork for ease

of handling, to make this first outline.

Now cut away all the parts of the eraser which are not in the design. Take care here! Many a design has been ruined by not concentrating at this stage.

Design a letter or monogram. This was designed with double pencils. The thinnest parts of the letter were made a little thicker.

Transfer this design to an eraser, making sure that it is back to front.

Carefully cut round the outline with a sharp knife.

Then cut away all the parts which are not in the design.

You can use a stamp pad from a stationers but the colour range is very limited, or a multi-coloured stamp pad from a specialist supplier. If you make your own stamp pad you can mix the colours to exactly the shade you require. To make your own, simply fold a kitchen towel to make a pad and put it on a saucer. Bottles of concentrated watercolour work very well as the ink for

stamp pads, or you can mix up some gouache and use that. Drop the concentrated watercolour or gouache on to the kitchen towel pad. Press on your rubber stamp and make a few test stamps. Unless you have been very meticulous, you will probably have to cut away more of the eraser to achieve a clean stamp.

Make your own stamp pad from a folded kitchen towel and concentrated watercolour or gouache. Try dropping two or more colours on to the pad for an interesting effect.

Use rubber stamps to make personalised wrapping paper and gift tags, with repeat designs and patterns.

You can also make rubber stamp designs which are not letters. Holly leaves and berries can decorate cards and gift tags for Christmas, bells for a wedding, a key for an eighteenth birthday. Rubber stamps can also be very effective when used as repeat designs and incorporated with pieces of calligraphy.

is une when it's happy
for me, oh how happy
clothes on, oh how much
shall be. No more church
parade on Sundays, no more
putting in for leave. I shall
kiss the sargeant major,
how I'll miss him how he'll
grieve. And when they ask
us how dangerous it was oh
we'll never tell them, no
we'll never tell them We spent
our pay in some cafe and
bought wild women night
and day, was the cushiest
job we ever had And when
they ask us the reason why
we didn't win the Darda
nelles oh we'll never tell
them There was a front but
damned if we knew where

country the normal setting of the battles taking place day and night, month after month. Evil and the incarnate fiend alone can be master of this war, and no glimmer of God's hand is seen any where. Sunset and sunrise are blasphemous, they are mockeries to man, only the black rain out of the bruised and swollen clouds all through the bitter black of night is fit atmosphere in such a land. The rain drives on, the stinking mud becomes more evilly yellow, the shell holes fill up with green white water, the roads and tracks are covered in inches of slime, the black dying trees

never cease. They alone plunge overhead, tearing away the rotting tree stumps, breaking the plank roads, striking down horses and mules, annihilating, maiming, maddening, they plunge into the grave which is this land: one huge grave, and cast upon it the poor dead. It is unspeakable, godless, hopeless. I am no longer an artist interested and curious, I am a messenger who will bring back word from the men who are fighting to those who want the war to go on forever. Feeble, inarticulate will be my message, but it will have a bitter truth, and may it burn their lousy souls.

FROM OUTLINE. PAUL NASH

They shall not grow old, as we that are left grow old: Age shall not weary them nor the years condemn. At the going down of the sun and in the morning LAWRENCE BINYON

WE·WILL·REMEMBER·THEM

(On the previous page.) Part of a large panel about the First World War. Appropriate texts were selected, as well as First World War songs. A poppy rubber stamp was made and this was stamped throughout the piece, so that the effect is of poppies falling and coming to rest in a thick carpet at the bottom – similar to the Remembrance Ceremony at the Albert Hall each year, where a poppy is released from the ceiling for each soldier who was killed in that war.

(Reproduced by kind permission of K. Carby)

Illumination – working with gold

There is nothing quite like gold for making a piece of calligraphy look special. The people in medieval times knew this, and the miniatures which contain gold are called *illuminated*, because it looks as though the light actually comes from the pages themselves. When you have used gold in your work, turn it in the light and it too will look illuminated.

Gold paint and ink

There are different ways in which gold can be used. Gold coloured paint or ink is probably the cheapest, but not necessarily the easiest to use. The metal used in the gold paint is heavy, and falls to the bottom of the palette. It needs frequent mixing, otherwise you will be applying only water mixed with the medium. Similarly, the metal falls to the end of the nib when gold paint or ink is fed into a pen. You will need to refill the pen far more frequently than normal to counteract this, or the letters will look patchy.

Some gold paints can be burnished or shined when they are dry. Place a piece of *crystal parchment paper* or *glassine* over the gold, and gently burnish with an agate burnisher, the handle of a metal knife or the back of your fingernail. (Crystal parchment is a non-stick paper which is used in gilding and available from specialist paper shops. For metal paints and inks you may find that baking parchment, used in cooking, is perfectly adequate. When using real gold, however, crystal parchment is to be preferred.)

If the gold starts to look shiny, then burnish it again without the crystal parchment. This should make it even shinier. You may

be able to burnish patterns into the gold paint. Put a piece of crystal parchment over the gold, press in the point of a 4H or harder pencil to make a pattern of dots. It is even more effective if you use a pencil burnisher as then you can burnish straight on the gold without the crystal parchment. You can emboss patterns of dots and lines into the gold with the pencil burnisher.

Gold powder

Real gold is available in three forms, *powder, block* and *leaf. Gold powder* is rather difficult for the beginner to handle, but it is cheaper than a gold block. Gold powder needs glue added to it to make it stick to the paper or vellum, otherwise it can be brushed off easily with the hand.

Gold powder is sold by the gram from specialist suppliers. In a small jam jar, palette or other small container, mix 0·5 gm with 8 – 10 drops of gum arabic and a small amount of distilled water. (The compound will look like mud!) Fill the container to the top with water, stir, then leave it for the gold to settle. Decant the water to another pot with a lid, or a small jam jar. This water may contain some gold, and should not be thrown away. Keep it to add water to gold for mixing, and to wash out the brush you have used for gold. (I keep a brush specifically for gold, which is not used for any other paint. This means that the gold is never adulterated by any paint which may remain in the brush, nor is any gold wasted by the brush being washed out in water which will be thrown away.) The gold should now be ready to try.

If there is too much gum arabic the compound will look rather brown, and it will not burnish very well. In this instance, fill the container to the top with water again, stir and pour off the water. You may need to repeat this a few times if the mixture is too sticky with the gum. If there is not enough gum, then the gold will not adhere to the paper, and in this instance, a drop or more of gum arabic should be added.

Some scribes prefer to use different glues, such as gelatin or fish glue (seccotine), and some suggest grinding the gold to make the powder finer. Experiment if the finished effect is not what you expect.

In a small jam jar, add 8 – 10 drops of gum arabic to 0·5 g gold powder.

Fill the jar with distilled water and stir.

Allow the gold to settle.

Pour off the excess water.

Gold block or shell gold

A *block of gold* for gilding is often referred to as *shell gold*, because it used to be sold in mussel shells. It is a small block, about the size of a quarter pan of watercolour.

It may seem rather extravagant when using this gold for the first time, but if you wash the mixing brush in distilled water, which is then saved, the water can be decanted and all the gold contained in the washings used again. This gold is already mixed with sufficient glue to make it stick to paper or vellum. I have often found that shell gold contains sufficient glue so that it is not necessary to add more gum arabic when using the washed out gold.

Shell gold is used in a similar way to watercolour. Add distilled water to the tablet, which usually comes in its own tiny white palette. Mix up a reasonable amount of the gold. Do not try

to economise by mixing up only a little, as it is more difficult to use. The gold is then applied as paint, or fed into a pen for writing. As with manufactured gold paint, the gold is heavy and falls to the end of the pen or brush, so both need charging much more frequently than usual. It is best to apply two thin layers of shell gold, rather than one thick layer when painting.

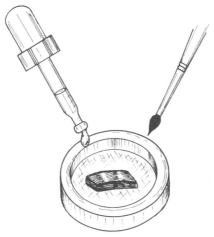

Add drops of distilled water to the gold block in the palette.

Using gold in this way is expensive, especially over a large area. Gold is most effective when used in moderation. Try adding just a couple of gold dots between the words in a title, or a few tiny gold squares to dance around your letters, or write just one letter or word in gold. This will probably look much better than large areas covered with gold. It is the contrast between flat colour and the sudden flash of gold which makes the precious metal so effective. Too much gold will not give that contrast.

Shell gold burnishes well to give a beautiful shine. When the gold is completely dry, cover it with a piece of crystal parchment. Gently rub over the paper covering the gold with an agate or haematite burnisher. Remove the crystal parchment and rub the burnisher straight on to the gold. The burnisher polishes the metal.

You can push patterns into the gold with a pencil burnisher, as before. A most effective use of the pencil burnisher is with tiny gold dots. Simply twist the point of the pencil burnisher into the gold and it really will look as if your work is illuminated!

Twist the point of a pencil burnisher into a tiny spot of gold.

For a greater contrast, cover the shell gold with a piece of bond typewriting paper, or layout paper. Burnish the gold through this. This will simply flatten the gold. You can then push a pattern into the gold with a pencil burnisher. The pattern will show up clearly as it will be shiny in contrast to the flat gold.

Remember to keep the distilled water in a small screw top jar or jam jar. Use this to mix the shell gold, and to wash out your brush. (You can also save the tiny amount of gold left on the nib and reservoir by washing these in this water, but only do so if the tools were very clean to start with. Do not allow any paint or dirt to get into the distilled water pot as it will affect the gold if it becomes mixed with it.)

Once all the gold has been used from the palette, start to use the gold which has been washed out into the jam jar. Allow the gold to settle at the bottom of the jar, then pour the water into another pot or jar. Sometimes you can use the gold straight away, as there is sufficient gum in the gold to make it stick to the paper. Try the gold first, and if it can be brushed off the paper, you will need to add gum arabic as explained on pages 167 – 168.

Gold leaf

Leaf gold on a slightly cushioned base can look dramatic in a piece of work, but is probably the most technically difficult gilding to do.

You will need special tools and materials for this gilding. First

of all, you need sheets of gold, or *gold leaf*. There are various qualities of leaf gold, some for gilding, some for picture framing, some for sign writing. Gold for gilding is 23·5, or 23·25 carat fine gold. It is sold in books of 25 sheets, which are about 8 cm square. There are two thicknesses of this gold, single and double, sometimes called *extra thick*. It is also sold as sheets attached to a backing sheet, called *transfer gold*, or as loose sheets.

Gold is difficult to handle. The leaves are so fine that the slightest movement can cause them to stick to themselves, crumple and be unusable. Because of this, although it does not give such a high shine, I usually start beginners with transfer gold for the single sheets, and loose gold for double sheets. You will need single *and* double sheets for gilding on gesso. Gesso is a plaster based compound. Gold leaf sticks to gesso, and so is raised on a cushion from the surface of paper or vellum.

Handle the gold very carefully. Make sure that you are feeling calm, that there is no draught, the windows are not open, and, preferably, no-one else is in the room. Alert the family to what you are doing so that they do not open the door suddenly.

Hold the book of gold from the centre fold. Starting from the back, carefully let one sheet of gold fall on to the table. Cut the gold you need from this piece. Put the rest of the book of gold on to the surface, and place it to one side, so that it is not knocked by an arm, or brushed by mistake.

You will also need a burnisher. These are made of polished haematite, psilomelanite or agate. Agate burnishers are most common, and although they are not quite so effective if the atmosphere is very humid, I have used one for all my gilding with no great problems.

Burnishers are available in different shapes for various purposes. Flat, wide ones are useful for burnishing large areas of gold. Pencil burnishers tuck the gold around edges and burnish patterns on to the gold leaf. Dog-tooth burnishers are good for smaller areas.

There are different shapes and sizes of burnishers.

To start with, a dog-tooth burnisher is all you need, with a pencil burnisher as well if you wish (although this can always be purchased later). Choose a dog-tooth which is quite substantial, rather than a small delicate one, as it will be more robust and easier to handle. However, do not select one which is too large, about 7 mm in diameter is about right. Although it is tempting to touch the polished smooth surface of burnishers, try not to handle the part which will come into contact with the gold. Any grease on your hand will transfer to the gold, which will then stick to the burnisher. Any roughness in handling may damage

the smooth surface, and will again affect your gilding. It may even ruin the burnisher which, if it scratches the gold, makes the finished effect unsatisfactory.

You will need a small piece of *silk,* about 15 cm square, perhaps an old handkerchief, or a scrap from the sewing basket. This is used to polish the burnisher before gilding, and at frequent intervals when gilding, to remove any grease, or any tiny pieces of gesso, or gum which may have stuck to it.

I would also recommend a *new* pair of *scissors* which are used only for gilding. They do not need to be particularly large, but they must be clean, free from grease, and without any damage to the blades. Any nicks along the blade will make the gold stick to them. You can use a gilder's knife and cushion to cut the gold, but scissors will do just as well.

Crystal parchment is a non-stick paper which you can buy from specialist suppliers. Although baking parchment can be used quite effectively for powder gold in very small amounts, for gilding with leaf gold, crystal parchment is better.

Gilding tools ready for use: 1. Single transfer gold 2. Loose double (or extra thick) gold 3. Soft brush 4. Breathing tube, or straw 5. Pencil burnisher 6. Piece of crystal parchment. 7. Dog-tooth burnisher 8. Scissors 9. Small piece of silk.

Other items which you will need are a *typewriter eraser*, shaped like a pencil, which can be sharpened to a point, and a *breathing tube*. You can make a breathing tube with a roll of paper, or with a hollowed out piece of bamboo. It does not need to be very long, only about 10 – 15 cm. You can use a drinking straw, but those made of plastic tend to condense the moisture in breath, which then drips out of the straw and can ruin work. As long as you shake the straw frequently to remove the moisture and dry it, plastic straws are adequate. I was very fortunate to be given a bundle of waxed paper straws by a student. These are ideal for use as breathing tubes because the moisture does not condense so readily.

Before you start any gilding, lay out all the tools and equipment so that they are readily and easily to hand. It is best to get into a routine when gilding so that it becomes almost automatic, and that tools are always put down in the same place, and are therefore easy to reach.

When you start to gild, begin by being not very ambitious. Tiny dots and squares will be sufficient to enable you to work out the method, and become used to the procedure. If your first project is to copy a medieval miniature, then you will find gilding difficult, and probably give up in the attempt. Start small, and gradually increase the area for gilding. It is a technique which needs practice. Only your own trial and error will show you exactly what you can do. It is also worthwhile having a notebook where you keep a record of your work; what you tried and whether it was successful. At times gilding can seem most capricious. Gilding one piece of work on two consecutive days can mean two different results. Exactly the same time, weather conditions and gesso and yet one day the gold will stick and not the next.

Gilding with leaf gold

There is a number of ways in which pieces of leaf gold can be attached to paper or vellum. It is likely that the very earliest illuminators did not use gesso, and that this was only applied at the height of book decoration in medieval times.

Probably the earliest gilders used *glair*. This is beaten egg white. Separate the egg and put the white into a bowl. Beat it until it is stiff and then leave it overnight. The liquid under the froth is used for gilding, so this should be carefully decanted into

a smaller container.

You will need to experiment when using glair. If the weather is cold and damp, glair can be used as it is. However, if the atmosphere is dry, you will need to add a little water to the glair, although exactly how much will depend on the humidity in the atmosphere.

Glair is applied with a fine brush, or fed into a nib. Before it dries, lay a sheet of loose gold over the glair. Put a piece of crystal parchment over the glair, and rub it gently with a burnisher. On a test piece of gold, try rubbing the gold itself with the burnisher to bring up the shine.

Once it is completely dry, possibly after a couple of days, the gold can be burnished directly. If the glair is covered and made airtight it will go bad, so it is best to prepare only small amounts and throw the remainder away. Add drops of water to glair that has dried out to make it usable again.

Glair can also be bought from specialist suppliers. B.S.Glair needs to be diluted with water. Simply paint it on and then gild straight away. Glair is used for gilding by bookbinders as well.

Gelatin, used for cooking, can provide the gum to stick leaf gold to paper or vellum. It usually comes as a powder which is dissolved in hot, but not boiling, water.

For gilding, use a ratio of 1 : 4, that is, one part gelatin to four parts of hot water. If you use measuring spoons, 1 ml of gelatin should be mixed with 4 ml of hot water, and will give you a lot of gelatin to use. Gelatin begins to set as it cools, so it is best to use it while still quite warm. It flows quite well from pen and brush. Lay a sheet of gold on to the gelatin as soon as it begins to set, and then allow to dry. Because gelatin is quite soft even when it has set, burnish only through crystal parchment paper, and then very gently!

Modern preparations, which are not too difficult to find, can also be used for gilding. *Acrylic glues* for sticking wood together, *PVA* and *cryla gloss medium,* used in artwork, can also be adapted for gilding.

All are best applied with a brush, and layers can be built up so that the surface for the gold is slightly raised. Gold sticks very well to these surfaces, but they do tend to show the brush marks, and do not give a completely smooth surface. Brush the area to be gilded with the compound and allow to dry. The stickiness is reactivated by breathing on the medium, and a layer of leaf gold then laid on. Burnish through crystal parchment, and then very

gently on the gold itself.

A more natural glue for attaching gold is *gum ammoniac*. This is bought either as a liquid or in lumps, which feel rather rubbery. In fact, gum ammoniac is similar to natural rubber in that it is a milky liquid from a plant.

The liquid can be used straight away, but it does lose its sticky properties fairly quickly, and unless you plan to gild a very large area, it is probably more economical to buy lumps of gum ammoniac.

To make the liquid, put a few lumps of the gum into a small jam jar or other container and simply cover with distilled water. Leave this to soak for some hours, preferably overnight, stirring occasionally to help dissolve the gum. The resulting milky liquid should then be strained to remove the impurities. Cut about 10 – 15 cm off the foot of a clean, old pair of tights, and stretch this over the top of a jam jar (about 500 gm), securing with a rubber band or string, if necessary. This will strain the gum ammoniac. Pour the liquid through the tights and the resulting liquid is then ready to use. Although it is not difficult using the gum without colour, you may prefer to add just a tiny drop of food colouring to the liquid. Gum ammoniac does not last long when it has been made into a liquid, and it is best stored in the refrigerator. It can still be used even when it has developed a mould. Simply re-strain as before.

Put a couple of lumps of gum ammoniac into a small jar.

Cover with distilled water and leave overnight.

Stir carefully.

Strain through old tights into a clean jar.

Gum ammoniac can be applied with brush or pen, and works particularly well when used for letters. Leave the gum to dry, and it will gradually lose its milky look and become clear. Breathe on the area where you have painted or written to re-activate the glue and place a piece of leaf gold on top. Because it is so soft, just press down on the gold with a piece of silk. You can burnish very gently with a burnisher through crystal parchment paper, but the heat of burnishing may cause the ammoniac to soften and the gold to rub off.

Water gold-size can be bought from specialist suppliers, it is a yellow liquid which is painted on to paper or vellum. It can also be used in a pen. Take care when using water gold-size, as the yellow dye is powerful, and it can discolour paper and vellum. Stir the liquid thoroughly before using. Apply the gold size and wait until it is dry. Then breathe on the area where it has been laid. Lay on a piece of leaf gold, and burnish carefully through crystal parchment paper. Test a small area before burnishing straight on to the gold. The water gold size may be too soft for this. Do not confuse water gold-size with Japan gold-size. Japan gold-size is an oil-based product used by picture framers and furniture restorers. It will spread when painted on to paper and vellum, and the oil base will ruin your work.

Gilding on gesso

Gilding on a gesso base is a real test of the illuminator's skill. Gesso makes a slightly raised cushion on which the leaf gold is stuck. Although it is possible to buy gesso from some specialist shops, it is much better to make your own, as you can then vary the formula slightly for the particular occasion.

Gesso is a mixture of slaked plaster of Paris, lead carbonate, glue and sugar. This is ground together with distilled water and a tiny pinch of Armenian bole for colour.

If you find it difficult to locate slaked plaster, you can slake your own but it takes some time. You will need about 500 gm of fine dental plaster (dentists can often supply this). Pour cold water into a 7 litre (two-gallon) bucket, almost to the top, and gradually add the dental plaster, stirring all the time with a long wooden or plastic spoon. Continue stirring for about an hour. If you do not do this, the plaster may actually set. The water will probably heat as you slake the plaster. Leave the plaster and water, loosely covered, in a cool place for 24 hours. Gently pour off the water, which will now be clear, leaving the wet plaster powder at the bottom of the bucket. Pour in more cold water, almost to the top of the bucket, and stir for about 15 minutes. Leave this for 24 hours, and repeat the pouring off, adding water and stirring process each day for 7 days. Then repeat this process every other day for 3 – 4 weeks. Finally pour off all the water. The plaster should now be gently turned out on to a clean piece of material. This should ideally be muslin, but I have found that an old pillow case works just as well. Squeeze the water out of the plaster, and then peel the cloth away from it. Divide the plaster into about four smaller portions and allow to dry in a clean, but not air-tight, container. Make sure that it is not near anything which contains iron, because this will discolour the plaster. When it is completely dry, it can be stored until ready for use in an air-tight container.

To make gesso, you will need:

a pestle and mortar (or a ground glass slab and muller)
a rubber or plastic pliable spatula
a piece of baking parchment (silicone paper)
 about 20 cm square
a small spoon – a salt spoon or small measuring spoon
a blunt knife

The ingredients:

8 parts of slaked plaster of Paris powder
**3 parts of lead carbonate (white lead)*
1 part sugar (preserving sugar or brown coffee sugar)
1 part fish glue or seccotine (this does give a rather brittle mix, and rabbitskin or calfskin glue is preferred, but more difficult to obtain)
a tiny pinch of Armenian bole, just enough to give the mixture colour
distilled water

**lead carbonate is poisonous. Store very carefully, and do not allow it to come in contact with food. Use the tools for making gesso only, and do not keep them, or the ingredients, in the kitchen.*

To make the gesso:

1 With the blunt knife, shave some plaster from the side of the lump. Heap the powder in the small spoon, and gently scrape the knife along the top so that the powder is level. Measure out eight spoonfuls, and put them on the silicone paper in separate heaps. Having separate heaps like this helps you keep count.

Heap the dry ingredients on the silicone paper so that you know how much you have measured out.

2 Put about a teaspoonful of sugar into the pestle and mortar and grind it until it is a powder. If you are using a ground glass

slab and muller, use this to make the sugar into a powder. Measure out one level spoonful of sugar as before, and put the sugar pile on the silicone paper. Wash and dry the pestle and mortar or the slab and muller.

3 Measure out three level spoonfuls of lead carbonate, and put these in heaps on the paper.

4 All the dry ingredients have now been measured out. Grind them together with a small pinch of Armenian bole, just to add colour, so that they are mixed to a *very* smooth powder. This takes a long time, and you will need to grind the mixture dry in a pestle and mortar for at least 15 minutes. Keep scraping the powder down from the sides of the mortar, otherwise the mixture will be uneven.

5 Now add the glue. Seccotine usually comes in a tube or plastic bottle. Squeeze the glue slowly and gently on to the spoon until it just fills it. Put this into the mortar, and scrape the spoon so that as little glue as possible remains in it.

6 Add distilled water, drop by drop, until you have a thick creamy paste.

7 Now continue grinding, stopping frequently to scrape the mixture down from the sides. In all, you should be grinding the mixture for between 25 – 30 minutes.
 (If you are using a ground glass slab, put the glue in the middle of the glass. With the pliable spatula, put the other ingredients on to the glue, and add a tiny pinch of Armenian bole. Mix together, and then gradually add drops of water until a thick creamy paste is formed. You can either grind the whole mixture with the glass muller for a similar length of time to that in a pestle and mortar, or smaller quantities of the mix can be ground separately for a couple of minutes. You will then need to mix the whole lot together, however, to ensure that the individual ingredients are evenly distributed.)

8 When the grinding is complete, scrape the gesso with the flexible spatula from the pestle or muller, and also scrape it down from the sides of the mortar.

9 With the spatula, carefully put small cakes of the gesso, about 1·5 – 2 cm in diameter, on to the silicone paper. Some scribes prefer to make one large cake, and divide this into sections before

it is completely dry, but I find it easier if the gesso is already in smaller quantities.

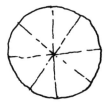

If you do make one large cake, divide it before it dries completely as though you were cutting a cake. This results in even proportions of the whole mix in every section.

The ingredients can be varied for the weather conditions or to attain a higher burnish:

For very hot weather:
8 parts plaster
3 parts lead carbonate
1·5 parts glue
1·5 parts sugar
This is also a good mix for using with platinum, palladium or aluminium leaf, which do not adhere to gesso so readily.

For a higher burnish:
9 parts plaster
3 parts lead carbonate
1 part glue
1 part sugar
Because this mix has less sugar and glue, try it out only when you are confident about gilding, otherwise you may have difficulty getting the gold to stick.

Allow the gesso to dry in a cool and dust-free place. Once it has dried, it can be placed in an airtight container for storage. Gesso keeps for some time, even years. It is better if the gesso is allowed to dry before it is used, although in an emergency it can be mixed and used straight away.

Preparing gesso for use

To re-constitute gesso, put a small cake, or one section of a larger one, into a small jam jar or similar container. If possible, break it into smaller pieces – but it does not matter too much if you cannot do this. Prop the jar so that it is tilted. Add a couple of drops of distilled water. Cover the jar loosely with a piece of paper and leave for some hours, preferably overnight. The water gradually softens the gesso and it is much easier to mix. The following morning add more water, drop by drop, and stir gently with the end of a paint brush or similar tool. Vigorous stirring will introduce air, and air bubbles make gilding more difficult. Experience will indicate exactly the correct mix for gilding, but initially try to achieve the consistency of thin single cream.

Preparing gesso for use: Put a small cake of gesso into a tiny jam jar tilted at an angle. Add two or three drops of distilled water, and leave overnight.

Add more drops of water, or a mix of water and vellum size. Stir very gently until the mix is the consistency of thin single cream.

Vellum size

Vellum size can be added as part of the liquid to reconstitute gesso. It increases the stickiness of the gesso without significantly reducing the brilliance of the burnish.

It is easy to make your own vellum size:

1 Cut a handful of vellum scraps into small pieces.

2 Put these, together with a litre of water, into a large pan, and bring to the boil.

3 Reduce the heat, and simmer until the liquid has been reduced by half.

4 Cut the foot from a pair of clean, old tights, and stretch this across a heatproof jug.

5 Pour the liquid through the tights, which will retain the vellum scraps.

6 Transfer this liquid to a clean jar and leave for at least two weeks. Initially the vellum size sets to an amber jelly. (This is the stage at which it is used as a glue in picture framing.) It is used for gilding when it changes to a liquid.

To reconstitute gesso using vellum size, add an equal number of drops of vellum size as water. If you use too much size the gesso will be too sticky and the burnished gold not so brilliant. Vellum size will keep for about a year in a refrigerator.

Using gesso

Before being fed into a pen or used in a brush, the gesso needs to be mixed carefully, but not energetically. It is important that each pen or brush stroke contains similar amounts of plaster and other ingredients, especially the glue. If you take gesso from around the edge, without stirring, the components will gradually separate, and the end mix will not be the same as the beginning.

Removing air bubbles

Gesso is notorious for containing air bubbles. No matter how careful you are, some mixes seem almost to froth. There are two ways in which the bubbles can be reduced.

First, if the mix itself seems to contain too many bubbles, add a tiny drop of oil of cloves, available from chemists or pharmacists, and stir gently. The oil disperses most of the bubbles.

Second, once the gesso has been laid, prick any visible air bubbles with a sewing needle.

Laying gesso

Attach the paper or vellum which you are using to a sheet of plate glass with masking tape. Plate glass is readily available

from glass merchants. Ask them to grind the edges so that they are not sharp. As an additional precaution, put masking tape around all four edges. Alternatively, students have used large bathroom tiles and the glass shelf from a refrigerator quite successfully. You need a cold surface so that moisture from breath condenses readily.

Tape the vellum or paper with masking tape to a piece of plate glass before you start to transfer your design or lay any gesso.

Gesso can be laid with a brush or pen, although a quill is preferable here, especially if it is a bubbly mix. The action of the gesso passing through a quill reduces the number of bubbles. When cutting a quill for laying gesso, make the slit longer than usual. To feed gesso into a pen, use the brush to gently stir round the mixture, and then charge the pen. Wash the brush frequently in clean water. Before laying gesso with a brush, wash it carefully in clean water, and wipe it dry, squeezing out as much air as possible.

Start by laying very small amounts of gesso. Begin with small dots, and gradually increase their size. Pull the dots into squares and stars, until you feel happy with handling gesso. You need a degree of speed in laying gesso. Start in one corner, and quickly pull the gesso into the required shape. Add more gesso when necessary, but always before the previous area has dried. Once it has dried, or even formed a surface skin, there will be a marked line. This can be scraped away when the whole area has set, but it is still best to try to avoid this.

To write letters with a pen or quill, it may be best to start with some indication of where the letters are to go. If the letters are completely drawn out then you will lose all spontaneity, but if

there are faint pencil marks showing where the letters begin and end, then that will leave you to concentrate on laying gesso. It is best to start with small and simple letters, which can be written almost with just one stroke. Versals and built up letters can be written once the technique is more familiar.

Leave the gesso to dry for some hours. The length of time depends on how humid it is, but it is better to allow more time than less. The surface of the gesso may appear dry, but it can still be quite soft underneath, and any scraping or burnishing will cause the surface to crack. It is probably best to leave it overnight to dry.

Scraping gesso
Occasionally the gesso will have dried completely smooth, and no changes will need to be made to it before gilding. Often, though, there are tiny bumps and dips, and, to achieve a good burnish, it is best to remove these. Some scribes feel that scraping the gesso also makes it easier for the gold to stick.

A knife with a curved blade is ideal for this, and the surface should be carefully and gently scraped. You must watch what you are doing all the time. Do not scrape so vigorously that all the gesso is removed, and the surface of the vellum or paper revealed. Take care also with the shape of the gesso. You want to aim for a layer of gesso, which is not too proud, with gently sloping sides. Avoid a plateau shape surrounded by steep slopes. This is the point at which air bubbles can be scraped away. If any bubbles remain in the dried gesso, the gold will not stick easily, and this will be obvious when you burnish. Brush away all the powder which has been scraped, taking care not to inhale, as it contains lead.

Laying the gold leaf
Gilding can be frustrating. Seemingly ideal conditions do not always mean that gilding is easy. In a way, you want to try to emulate the conditions in a medieval cloister or scriptorium.

The gesso should be cold, but not refrigerated. Cold gesso means that the moisture from warm breath condenses readily on its surface thus reactivating the glue.

Humidity is also important. Although I do not use a hygrometer to assess the relative humidity, the most suitable conditions are those when the relative humidity is between 63 and

73 per cent. Humidity can be increased by having bowls of boiling water near to the gilding area (but not on the gilding area in case of accidents). Certain winds can be more drying than others.

It is a matter of trial and error to achieve good conditions for gilding, but those very early in the morning, around dawn are better than later in the morning, and certainly many illuminators find gilding after 11.0 a.m. or 12 noon difficult. In the summer, with commissions for clients which have to be completed regardless of the weather, I usually gild at about 4.0 a.m. or 5.0 a.m., which also means that I am often finished before the rest of the house stirs – an additional advantage!

Set out your gilding materials as before. Have ready the burnisher, scissors, silk, crystal parchment paper, straw or breathing tube, and, of course, books of single and double gold.

This is the procedure for gilding on gesso:

1 Breathe on the burnisher and polish it with the silk.

2 If you are gilding a large area, mask off everything with pieces of crystal parchment apart from a section which is about 2 cm square. (If you are not very experienced, reduce this area by at least half).

3 Cut a piece of single transfer gold to easily cover the area you are to gild.

4 With the piece of gold in your hand, breathe on the gesso from a distance of about 5 cm. This should not be shallow huffs. You need the air from the bottom of your lungs, as it is the moistest.

5 Breathe three or four times, and immediately place the gold face down on this area. Press heavily with your fingers through the backing paper.

6 Now use the burnisher. Start fairly gently, and make sure that you pay particular attention to the sides, as this is where the gold is reluctant to stick.

7 Burnish the area completely, and then remove the backing paper. Replace this with a piece of crystal parchment, and then burnish again, but increasing the pressure a little.

8 Now, remove the crystal parchment and, very carefully, burnish straight on to the gold, again concentrating on the edges.

Single gold is very thin, and it is easy for the burnisher to pick up tiny pieces of of gesso powder, which will scratch the gold. Polish the burnisher frequently with silk.

9 Cut another piece of single gold, and repeat the process, but breathing only slightly on the gold.

10 If at this point there are any obvious places where the gold has not stuck, pinpoint these and breathe through the straw or breathing tube, having a piece of single gold ready to place on this area straight away.

11 Now cut a piece of double gold. Remember to start from the back of the book, allowing just one leaf, with its backing sheet, to fall on to the surface. It helps if you make a little snip with scissors in the gold with the backing sheet. This attaches the gold to the sheet and makes it much easier to handle. Cut an area which easily covers what you are to gild.

12 Huff very gently on to the gold, and place the double gold onto the layers of single.

13 Burnish the gold through the backing sheet.

14 Remove this paper, and replace it with a piece of crystal parchment. Burnish through this, and then onto the gold itself.

15 Gold will stick to itself, and now that the gesso is covered with a layer of double gold, you can begin to press quite hard. At this point you should be able to see a shine appearing on the gold.

16 There may be some double gold extending beyond the area which has been gilded. With a sharp knife, carefully lift this from the vellum or paper surface, and fold it back on to the gesso. Depending on the size of the area which you are gilding, this may cover the whole area.

17 Burnish again through crystal parchment, and then onto the gold itself. By now the gold should be developing a deep burnish.

18 Look at it from various angles, and make sure than it is burnished evenly, paying particular attention to the edges and any large flat surfaces. You may wish to put on one last layer of double gold in the same way as before.

19 When you have finished the whole area to be gilded, remove

any surplus gold with a large soft brush, taking particular care around the edges of your work. The process of gilding should have attached the gold sufficiently to the gesso such that it cannot be brushed off.

If there are traces of pounce or sandarac powder, the gold may stick to that, especially close to the gesso. Sharpen the point of a pencil-shaped ink or typewriter eraser. Gently rub away the gold, being specially careful near the very edge of the gilding, as the roughness of this eraser can remove the gold! When brushing away the sweepings do not brush over the gold, as the abrasive particles in the eraser could scratch the gold.

Mask off the area which is not being gilded.

Cut a piece of single gold to cover the area easily.

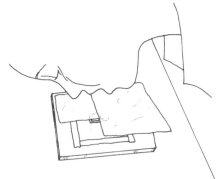

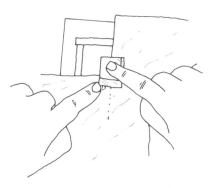

Breathe on the area to be gilded.

Quickly cover this with the single gold, and press down with your fingers.

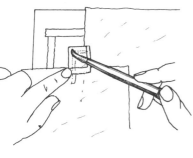

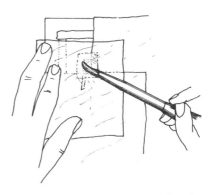

Using a burnisher rub over the whole area through the backing sheet, paying particular attention to the edges.

Remove the backing sheet, replace it with crystal parchment, and rub with the burnisher again.

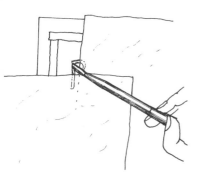

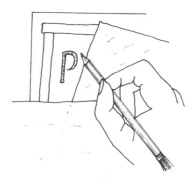

Remove the crystal parchment, and rub over the gold with the burnisher. This needs a delicate touch.

After adding more layers of gold and further burnishing, and when you have finished gilding the whole area, clean up the gold with a pencil-shaped ink eraser.

The depth of burnish obviously increases with the layers of gold. However, at some point, the layers of gold stick to themselves and not the gesso, and will flake off. Two layers of single gold and two of double will probably be a good number. Try an additional layer of double for a deeper burnish. Do not

skimp with gold. It is expensive, but too few layers of gold ruin the effect.

What to do when it does not work!
Despite all the breathing, checking on the relative humidity and bowls of boiling water, there are some occasions when the gold just will not stick. If the gold does not stick to large areas, then it is best to scrape off any gold which has stuck, and try again the next day – but perhaps at an earlier time.

If the gold does not stick to one or two small patches, then use the straw to reactivate the glue in just that area, covering the rest of the gold with pieces of crystal parchment, and add tiny pieces of single and then double gold to these spots. If even this does not work, then scrape the area with a sharp knife and go through the gilding process again.

As a very last resort, if the area where the gold will not stick is tiny and unobtrusive but spoils the work nevertheless, then carefully paint that spot with gum ammoniac, PVA or acrylic gloss medium. When it is dry breathe on it and place a layer of double gold on this. The gold will stick, but it will look slightly different to the rest of the work, so this cannot be done where it will show.

Despite all these problems with getting gold to stick, when it does and the shine on the gold is so bright that it is like a mirror, you will realise that all the anguish has been worth while. It is one of the most pleasing aspects of the craft.

Order of work
Gold does not always stick readily to gesso, but it seems to stick to everything else, particularly paint and ink! Gilding should therefore always be one of the first processes in a piece of work. For any work which includes gilding, writing and painting close together, this is the suggested sequence if you are using a piece of vellum. If you are using paper, simply leave out the stages which refer to vellum:

1 Prepare the vellum.

2 Transfer the outline for any design or pattern from your rough paste-up.

3 Rule up the lines.

4 Rub in gum sandarac where there will be writing on the vellum.

5 With a large piece of paper, cover the surface of the vellum or paper, cutting a window where you are going to lay gesso for gilding.

6 Lay gesso.

7 Gild, and remove any surplus gold.

8 Cover the area which you have gilded. I use a layer of crystal parchment, covered with a thin pad made from kitchen towels attached by strips of masking tape.

9 Complete the writing.

10 Complete the painting and decoration.

However, if the areas where you are to gild, paint and write are not close together, then it is often best to leave the gilding until the end. Raised gilding, by definition, is proud of the surface, and needs protection if it is not to be damaged. In this instance, write first, then paint and gild last of all.

Silver

It is possible to buy silver or white gold which comes in sheets, like leaf gold, and also as a powder or tablet, as with shell gold. White gold – gold with a high silver proportion – like silver, tarnishes quite quickly, certainly within ten years, even if it is in an airtight frame. You can seal the silver powder or leaf with a fixative, but this sometimes reduces some of the brilliance of the shine.

Silver coloured paint, usually aluminium, is probably the best, and also cheapest, alternative. This does not tarnish, but cannot be burnished to a bright shine.

If you want to use a form of leaf silver, then it is probably better to choose a completely different metal, leaf aluminium, platinum or palladium. Aluminium is quite cheap, platinum and palladium very expensive. You will need to choose a stickier recipe for gesso, such as that on page 181. Usually you can attach only one layer of the leaf because these metals do not stick to themselves in the same way as gold leaf.

6 · Ideas in Action

Having understood the basic techniques of the craft, you will soon be wanting to put your skills to good use. Calligraphy is not only very versatile but indeed useful and you will probably be finding yourself in great demand for writing names on certificates, or on cards for presentations, or even for more ambitious projects.

This chapter considers some of the ways in which you can use calligraphy, with ideas, and methods which may be helpful.

Labels

It is convenient and time saving if you can write out your own labels for jams and jellies, wine, spices and kitchen goods. Carefully written labels for files and other items in an office or for your own business will give a good impression.

Choose a style of writing which reflects what you are labelling, and perhaps add a drawing using the same pen.

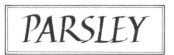
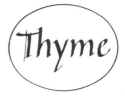

Labels for herbs

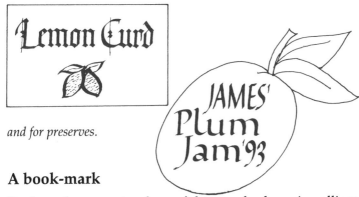

and for preserves.

A book-mark

Book-marks are not only useful to mark places in calligraphy books, but make very acceptable presents – a small token of appreciation, which can delight the receiver.

Essentially, a book-mark is narrow in shape, on a weight of card or paper which is not so heavy that it distorts the pages of the book, nor so flimsy that it creases and folds.

The shape of the book-mark determines your design. You cannot really consider anything of great length which will be square in shape. Given this, however, there are still many possibilities.

Decide what you will write on the book-mark. It could simply be 'Jane's book-mark', or it could be a quotation related to books, or to the recipient, or whatever.

A book-mark cannot be too large, and this will therefore limit the size of nib you can use, and the size of your writing. Try out a few different sized nibs and different styles of writing to see what fits best. If this is to be a present, it may be appropriate to also match the chosen writing style to the receiver – a very free casual style or a more formal hand.

When you are happy with your calligraphy and design, you will then need to choose a suitable paper or card. You may already have to hand a lightweight card or a heavy paper which can be used. However, you may also be a little reluctant to use a largish piece of very expensive, possibly handmade paper. There are many ways to overcome this difficulty. You can make a surrounding mount or tear round expensive papers in an attractive way. Simply cutting a small rectangle of paper which is stuck on to a cheaper card or paper will suffice.

Make a hole at the bottom of the book-mark with a paper punch and thread through very narrow satin ribbon or

embroidery silks. You can even stick on a piece of folded paper so that it marks the page.

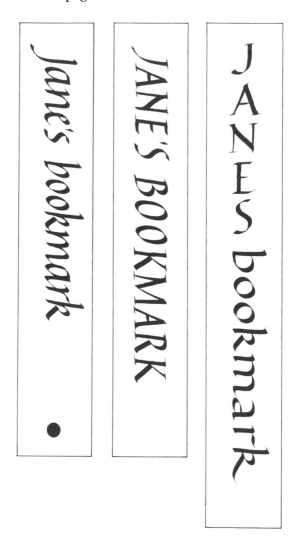

*Three ways of writing **Jane's bookmark.** The first in a cursive Italic, the second in Italic capitals, and the third in Round Hand capitals and small letters. Generally speaking the words work best when they are written horizontally, rather than vertically, as in the last example.*

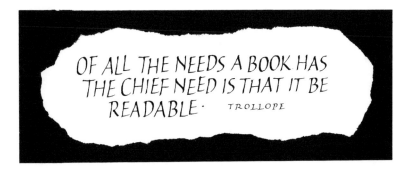

Two ways of writing a quotation for a book-mark. The first in free capitals on a piece of handmade paper, which has been torn to give a ragged edge; this was then mounted on a contrasting card. The second, rather more formal, written in Carolingian.

An invitation

A handwritten invitation makes an event really special. It does not even matter if the final version is printed, and the name added by hand. The fact that someone has taken the trouble to design it and write it out by hand in the first place is what makes it so different – and so much better – than a printed typeset invitation.

Match your style of invitation to the event. An informal birthday party warrants a different design, layout and chosen hand, to a formal dinner party or perhaps a wedding.

Write out the invitation in pencil, or very quickly in pen to see how the words can be set out on the paper.

An informal invitation could be written out with one size of nib, and all in the same writing style. You may want to add a decoration of some sort, perhaps with a rubber stamp (pages 163 – 165), or an embossed design (see pages 160 – 161).

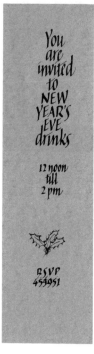

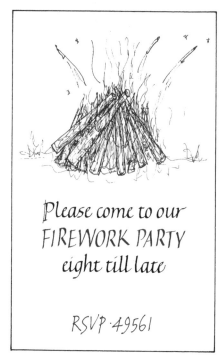

Two invitations – both informal. The first, written in Italic capitals was photocopied on to thin card and slipped into Christmas Cards. The second, for a bonfire party, could perhaps have even more informal calligraphy. The drawing was done in a minute or two with technical pens, and one was also used for writing the 'phone number at the bottom.

For a more formal invitation, look at the information which needs to be included. Certain phrases probably should be emphasised, and it is likely that it will fall naturally into separate lines. Again, write this out quickly in rough. Names, date, location are usually on different lines.

Decide on a particular hand, or perhaps a combination of hands. Write out the information which you feel should be the same size, and in the same hand. Then write the information which is smaller or larger in size, or in a different style.

If you have access to a photocopier, take a copy of your work. Then cut it up into separate lines. You may decide on a centred layout, in which case, simply fold each strip of words in half.

You may prefer a layout with a left margin, a right margin, or an asymmetrical design. In these cases, attach two tiny pieces of masking tape to each strip, or spray the back with an aerosol glue which will allow re-positioning, or use rubber solution glue. All these will allow you to put the strips of paper in different places as you work out your design.

Some designs work best when each line is not actually centred but the design is based on a central axis. To do this, attach the strips to the positions where you think they should be. Pin your work to the wall, or stick it there with two small strips of masking tape, and stand about two metres away. Hold a ruler at arm's length in front of you, and close one eye. Position the ruler to where the central line should be. Your lines should balance – there should be visually similar amounts of text on the right and the left sides of the ruler. Re-position individual lines as necessary. With a design like this, what is most important is that there is a central spine, rather than what happens at the edges of the design.

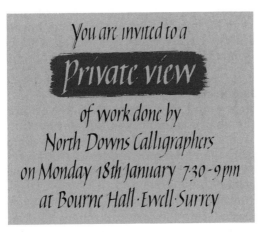

Two roughs for a Private View invitation, one in Italic and one in Uncials.

> You are invited to a
>
> **Private view**
>
> of work done by members of
>
> North Downs Calligraphers
>
> on Monday 18th January 7·30–9·30pm
>
> at Bourne Hall, Ewell, Surrey.

The Italic design was preferred, and the lines written in different weights and nib sizes to give emphasis to the most important elements. The words 'Private view' were written in masking fluid and covered with a wash of black ink.

You can, of course, alter the spaces *between* the lines, for emphasis. The most important information does not always have to be written in the largest letters. Sometimes, writing it smaller with a large amount of white space around can bring about the same effect.

Printing and photocopying

If your work is going to be printed, or if you are going to photocopy the final invitation, you do not have to worry too much about making a final neat version. Printers and photocopying machines can cope with pasted-up work. You need to make sure that you work is in dense black ink, even if it is to be printed in a colour.

If you are unhappy with one word, a letter, or even a line, re-do this and paste it into the correct position. You can mark the dimensions on your work with a pale blue pencil. This colour does not register on photocopiers or with a printing process. If

there are dirty marks or ink blots on your work, remove them by painting over with *Process White*. This is a dense white paint which is mixed with water, and will cover any mistakes. It is available from most art shops. If you can, take a photocopy of your work. There may be lines showing the edges of the strips of paper. These can be removed on the copy by again painting over with Process White. If you are having the invitations printed, you can choose any colour from the printer's range, as long as you have made a good black original copy.

A greetings card

Most greetings cards have writing on them somewhere. The whole design may be based on lettering, or it may simply be a message inside. You can make very attractive cards for friends' birthdays or other special events, or for festivals such as Christmas and New Year using your calligraphic skills.

It is always worthwhile keeping a note of any quotations, phrases, poems or pieces of prose which may be appropriate to write out at some point. A notebook with these written in means that you have a stock of sayings which you can use as the need arises.

Envelopes
The most important factor to take into account when designing cards is the envelope! There are few things more frustrating than making and lettering a beautiful card, which does not fit any standard envelope. Envelopes are not difficult to make (simply unstick an ordinary envelope to make yourself a template, enlarging or reducing it in size as necessary), but they do take time, and if it is to be simply put in the wastepaper bin, your efforts will not be worthwhile.

Designing your card
Make a few pencils roughs of your card. You may wish to include a drawing as well as words, or use a rubber stamp, make an embossed monogram, write the person's name in a resist or use any other technique which has been mentioned in this book. As you are working, the shape and size of the card will probably sort itself out.

If the card is a one-off, you may choose a handmade paper, or even a scrap of vellum, which can be backed with white paper and mounted on a contrasting card.

If the card is to be printed or photocopied, try to work out the design so that it can be printed on one side of the paper or card. This will considerably reduce the printing costs. It will only have to be put through the photocopier once, or only one plate will have to be made for printing.

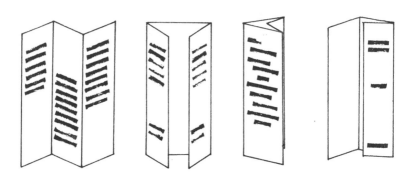

You can fold paper in different ways so that the printing appears only on one side. First a zigzag, then a double opening fold, and a design where the card folds flat but makes a triangle, and stands upright. On the right the card has been folded into three. Two sides are stuck to make the card more robust.

You can feed card through a photocopier, or you can use paper and fold it twice so that it is stiff enough to stand up. Always make sure that the folds are at the top and on the left hand side. Here you can design the card so that it can be photocopied, and then folded so that the message is inside.

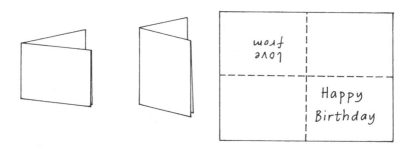

The folds should be at the top and left hand side of the paper.

This card was designed for a bank in London. The quotation seemed particularly apt for the recession at the time, and the chill wind blowing through the financial markets. It was written out in free Italic capitals. The words 'Christmas merry' were cut out and separated from the written design before printing. Most of the lettering was printed in green, and 'Christmas merry' was printed in red. Inside the card, the same idea for design and colour were used.

(Reproduced by kind permission of Dunbar Bank PLC)

HEAP ON
MORE
WOOD
THE
WIND
IS CHILL
BUT
LET IT
WHISTLE
AS IT
WILL
WE'LL
KEEP OUR
CHRISTMAS
MERRY
STILL

SCOTT

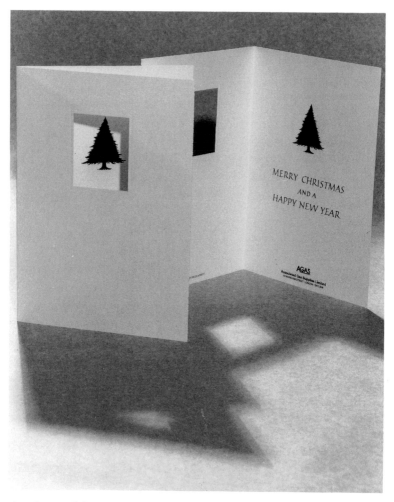

Another card for a company which wanted their card to be the one which was picked out of the pile and looked at. This was achieved by having nothing printed on the front! Inside the card the message and a Christmas tree were printed in green. The front of the card had a window cut-out which showed the Christmas tree. An embossed line surrounded the cut-out. This had to be done specially by the printer, who also trimmed the front edge of the card so that it looked as if it had been torn from handmade paper.

(Reproduced by kind permission of Agas)

Certificates

Writing names on a certificate is a job that calligraphers are often asked to do. Actually designing the certificate is a different matter all together, but is very satisfying especially if you are then asked to insert the name as well.

Some certificates look simple, but require a number of decisions to be taken before the design and calligraphy look right.

A Prize Certificate

Gardening and flower clubs often want prize certificates written out. Certificates which have few words are not necessarily easier to design than those which have many.

Decide what is the most important feature of the certificate. As these are one-off certificates, you could add colour to your work by writing different lines in gouache. Perhaps red would be a good colour, or maybe green for a garden club.

Try to add colour early in your design. It does make such a difference. Decide on the size of writing and style which you think best. There will probably be limits of size given to you. Remember to allow your calligraphy to breathe. Plan to have good margins around your writing and design.

Having written out the most important line, then work on the others. You may choose a more cursive hand or capital letters, or a different colour, to make a contrast.

Write out the information in rough. These were first experiments.

Cut your work into strips, and place them on a piece of paper which is the size you are to use. Do they fit comfortably in this space? You may need to alter the sizes or rewrite a line or two in a smaller nib, perhaps.

Decide whether you will be centring the text, or whether the lines will start from the same left or right hand margin.

Cut the style and words you prefer into strips, and place them on a sheet of paper, which is about the size of the final certificate. If you are introducing a second colour, rewrite the words in this colour.

You may choose to add a design or decoration to the certificate. You can draw simple flower or vegetable shapes with a broad edged pen, or perhaps your skills extend to line drawings. If you draw them in black, they can be photocopied on to lightweight card, which will save a lot of time.

Finally, each certificate will need ruling up. It will save time again if you make a template for this, if you have a lot to do. Simply mark the lines on a piece of paper, and transfer these markings to each certificate. Ruling up can be done at any time, even whilst watching television, or listening to the radio, especially if you have a portable rolling ruler, which will ensure that the lines are parallel.

Mix up enough colour for all the certificates, and write in that colour on all the certificates which you have to write. If you are centring each one, remember to attach the line you are writing with two tiny pieces of masking tape just above where you are to write (see page 140 – 141). This will help you with spacing and spelling.

When you have finished all the writing, and the ink or paint is dry, carefully erase all the pencil lines.

On rare occasions, certificates work out without too many problems. I was asked to design and write out a certificate for the *Teach Yourself Award*. The publishers had already roughed out a guide for the certificate. In fact, this was a very presentable attempt. The person who worked on this has a sense of movement in the letters, and, if it had been pulled out a little more, and there was a little more variation in the lettering, this would have worked well.

Although I was asked not to change the wording, I did make one change, and that was to put the date on a separate line.

I sent off a copy, and various changes were made.

The final certificate was written out on good quality 100 per cent cotton rag paper using Chinese stick ink and gouache for the name.

The original design which was sent to me by the publishers.

Changing only the position of the date and the shape of the certificate, this was the first attempt, with changes marked by the publisher.

THE TEACH YOURSELF BOOKS AWARD

Presented to

BRUCE COWARD

Manager & Trainer

THE HARBOUR BOOKSHOP
KINGSBRIDGE · DEVON

1992

Certificate in Bookselling Skills

The final certificate.

TOP MANAGER·FMA DIVISION

Andrew Ewan

SCOTLAND FMA BRANCH

1992

ALLIED DUNBAR

Not all certificates have to look conventional. Allied Dunbar PLC wanted something which would stand out from the rest. They are a very adventurous company to work for and do not reject the slightly unusual. Black paper was torn to give an uneven edge. The name and other details of the award were written on handmade white paper in gouache and Chinese stick ink. (Reproduced by kind permission of Allied Dunbar PLC)

A quotation

Sometimes a quotation almost falls into place, sometimes it needs a little work.

Choose your quotation. Write out in rough those which do not immediately seem to form a shape, or drop into lines. At this stage, do not even try to form separate lines, simply write as though there were no set line endings.

Read through what you have written. The sense of the piece may make natural breaks. Cut up your rough into these breaks, they may be one line, a short phrase, or a couple of sentences.

You now need to make more decisions. Are you planning the piece to be in blocks of text, or lines, or phrases? Will you write some parts larger or smaller, or in a different style, or will it all be the same size and style?

Place your rough, which you have cut up, on to a larger sheet of paper. Even at this early stage you should consider the margins around your work, and where it will be placed on the paper.

Re-write any sections which you are not happy with. Try them in a smaller or larger nib, or perhaps in capital letters, for contrast.

When you are satisfied with your work, the measurements can be transferred to a sheet of good paper, and the writing completed.

This quotation by Horace went through a number of stages. I wanted to combine an Italic and Uncial hand. I tried them in different colour combinations on various handmade papers.

This was one of my prayers·for a parcel of land
hoc erat in votis·modus agri non ita magnus
not so very large, which should have a garden
hortus ubi et tecto vicinus iugis aquae fons
and a spring of everflowing water near the house
et paulum silvae super his foret
and a bit of woodland as well as these

After many experiments, I settled for lighter coloured writing on black paper. I made a mask for drawing the lines, so that they did not extend beyond the writing. I also mixed the white quite thickly for the Italic writing, as I wanted the lettering to be solid and not patchy.

ALL THINGS SHALL
MELT AWAY AND
TURN INTO SONGS
WHEN SPRING COMES
EVEN THE STARS
THE VAST SNOW-FLAKES
THAT FALL SLOWLY
UPON THE LARGER FIELDS
KAHLIL GIBRAN SHALL MELT INTO
SINGING STREAMS

This quotation by Kahlil Gibran, the Lebanese philosopher, had been known to me for a couple of years before I felt that I was ready to write it out. When I did, the lines fell into place quite naturally. I used a fine nib and shades of blue and green watercolour. Perhaps I should have re-written it to smooth out some of the wrinkles, but I thought that I might have lost the spontaneity and liveliness of the piece by so doing. This is available as a colour limited edition print.

A single section book

It is not difficult to make a manuscript book, and, as it will give you a real sense of achievement and will delight the receiver, if made as a gift, it is certainly worth trying.

Texts of almost any length are suitable for books, although at first it will be better to select those that are not too long. Anything which will take more than eight or ten pages (four or five folds) to write out should be bound in more than one section in a book, and this is beyond the scope of what is being considered here.

Short texts, even one-line quotations do work well in book form, although you may be thinking of a poem or slightly longer piece of prose.

Having selected your text the next stage is to write it out. The finished size of the book will limit what you can write and how large the writing will be, so have these dimensions in mind from the beginning. The book can be longer horizontally – *landscape,* or longer vertically – *portrait.*

A portrait-shaped book *A landscape-shaped book*

Experiment with different sized nibs, and with different layouts, and then cut or fold the paper to the size of the final page. Often writing which looks acceptable on a large sheet of paper, is much too large when the finished book is considered.

A book, portrait-shape, which is set out conventionally has page margins where the bottom is twice the size of the top, and the sides three units wide. These are shown on the next page.

The accepted margins for a portrait-shaped book. The units can be any measurement of millimetres or centimetres, inches or fractions of inches.

However, you may well want to set your book out in a way which suits you and the text. Often unusual layouts are the best, as they catch the attention of the reader. Do not be afraid to experiment with setting out the text and the position of the text on the book page.

You can use almost any paper for a book. Ideally it should be of a weight which does not flop, but which is not so stiff that turning the pages is difficult. You can experiment with paper by cutting a piece to the size of the finished pages. Fold it in half, hold it at the fold, and the paper should just fall over. If it does not fall, then, conventionally, it is too stiff; if it falls easily, it is too thin. Yet my students have made beautiful books from thin Japanese tissue, as well as very thick handmade paper. Small, one-off books like this, which are not being used everyday like Memorial Books in churches, are often more attractive by using unconventional materials. Choose a paper which appeals to *you*, rather than one which bides by convention.

For a conventional book, the paper should just flop over when held at the fold.

Remember that the grain direction of the paper should be vertical for books. Look back at pages 114 – 115 for details on this.

A slightly heavier weight paper or thin card is best for the cover, although you could stick two pieces of the paper you have used in the book together with rubber solution gum to make a stiffer cover.

Always prepare a mock-up of your book, even though it is only a couple of folds. It is surprising how confusing it can be as to whether one page follows straight on from another, when pages are folded. You do not need to make the mock-up large, the paper can be scraps only a couple of centimetres high, but it will show you which page is linked to which.

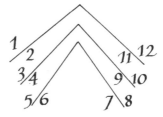

Make a mock-up of the pages in your book with scraps of paper.

You can include endpapers in your book, which can help to attach the cover to the book, as in this example:

With a knife and metal ruler cut four right-angled slits in both end papers. Match the end papers up to the cover and use a compass point to mark on the cover the beginning and end of the slits on the end papers. Make other slits on the cover with a knife and ruler between these compass points. Push the right-angled pieces through the slits in the cover. Decorate the protruding paper if you wish.

Decorate the cover as you wish, perhaps by embossing it or with rubber stamps. The title can be written in a decorative way, perhaps using a resist, a balsa wood pen or other special pen.

End papers can be stuck to the cover, or they can be attached in less conventional ways.

Decide whether you want the sewing of the book to be functional or decorative. If functional, choose linen thread, or buttonhole cotton, and start the sewing from the inside. If decorative, you could use very narrow ribbon, embroidery silk or something similar; and start your sewing from the outside.

To sew a single section book, measure the mid-point along the spine, and the two halfway points between this and the edges of the pages. Thread a darning needle with your chosen thread and push the needle straight through the mid point. Pull the thread through carefully, without yanking it, as it may tear the paper. Sew in the pattern as shown above, finishing with a knot or a bow. Trim the edges of the thread, or, if decorative, leave them long. You may like to fray the ends for additional decoration.

Zigzag books

Another way of setting out a text is to write it out as a zigzag, or concertina book. This can be set out so that the text and page are vertical *(portrait)*, or horizontal *(landscape)*.

Again you will need to decide on the size of nib, how to break up the text into separate pages, the style of writing, title page, and so on.

When planning your zigzag book, do not forget to take the endpapers into account. Each endpaper needs to be attached to the cover. Your book should be planned with an even number of

pages, which means an odd number of folds, otherwise you may be attaching a page with text face downwards to the cover.

Plan your zigzag book so that it has an even number of pages, with an odd number of folds.

Before writing out your book, check the grain direction of the paper (see pages 114 – 115). It should follow the line of the folds, otherwise folding will be difficult as the paper fibres will break.

For the covers, you can simply stick two pieces of paper together to make a slightly heavier weight cover. Or you can cover cardboard with matching or toning paper. The cardboard from the back of a pad of paper is ideal. Again, check the grain direction, (pages 114 – 115), which needs to be the same way as the paper. Cut two pieces of card which are slightly larger all round than the finished page size. Now cut two pieces of paper to cover the card. Measure the dimensions of the card, and add 3 cm to the length and breadth. If the cardboard you have chosen is very thick, you may need to add a few more millimetres to this measurement.

Place the paper face downwards on to a sheet of clean scrap paper. Measure the midpoint, and from this, mark on the dimensions of the card with a faint pencil line. Now mark on another rectangle which is 3 mm larger all round. With a knife and metal ruler, cut the corners away from this larger rectangle. If you have a bone folder, it may help to score along the faint pencil line, especially if the paper is thick. This can be done with care with a very blunt knife.

Using rubber solution gum or paper glue, paste all over the paper. Carefully place the card on your initial faint pencil measurements. Turn over the top and bottom edges of the paper. Push in the extra 'ear' of paper neatly before you turn over the sides of the paper to completely cover the card. Repeat this for the other card.

On your piece of paper mark on the measurements of the cardboard cover.

Now mark on another rectangle which is 3 mm larger all round.

Cut away the corners of this larger rectangle.

Paste all over the paper.

Place the cardboard so that it matches up to the faint pencil markings.

Turn over the top and bottom folds of paper, pushing it against the card so that it is a good fit.

Before turning the side flaps, push in the little 'ear' of paper with your fingernail, or a bone folder if you are using one. This makes for a very neat and tidy corner.

Decide whether you want your zigzag book to be held together when it is closed. You can cut a narrow strip of paper which fits easily around the finished book and then stick the two ends together. This can be slid over the book to keep the covers together. Before the paper is stuck, you can decorate it in some way, or perhaps write the title on it. You may wish to have ribbons to hold the book together. They should be attached before the covers are stuck to the book. Make holes in the covers with a bradawl or sharp point according to whether you want one set of ribbons or two. Measure the positions carefully. Push ribbons through these holes and make sure that they are stuck firmly with glue on the reverse of the covers. An ingenious way of closing the book is to have ribbons threaded through the whole book and its cover. Allow long pieces of ribbon for this, as you need to let the folds of the book open fully, rather than being restricted by the ribbon. Punch holes right the way through the book, as well as the covers for this method.

Decorate the cover in whatever way you wish. You may choose an all over pattern made with a rubber stamp, an embossed or an indented pattern. You could write the title and author of the piece on the cover itself, or on a separate piece of paper and stick it on. Be adventurous in the position of this paper; it does not have to be in a conventional place. Try it towards the bottom of the cover, to one side, wherever you think it looks best.

To keep the book closed you can: slide a 'tube' of paper over the book,

attach ribbons before you stick the cover to the book.,

punch holes through the book and covers and thread a long ribbon through them.

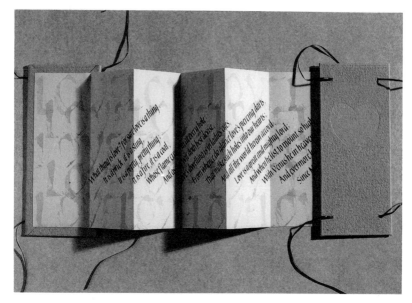

This Valentine zigzag book was not difficult to make. The large letters were written with an automatic pen and watery watercolour. A toning gouache was used for the poem, which was written at an angle. The same shade of purple ribbon was attached to the covers, which were covered with a pinky-purple rough paper. Before the paper was stuck to the card, a thin card was stuck on to the cardboard cover with the shape of a heart cut out. When the covers were covered with paper, this was pushed into the heart cut-outs. The heart shapes were burnished so that they were shiny, and the paper was smoother here. This formed a contrast between the rough paper of the cover and the heart shapes.

7 · History of Writing

The writing styles shown in this book have been adapted directly from alphabets used in documents in the past. The following brief overview of the development of western writing has been included to give a historical perspective to the various scripts.

Cave paintings
One of the first forms of communication, which cannot really be classified as writing, are cave paintings which can be seen in various parts of Europe and elsewhere. We may never know exactly what they mean, but there is little doubt that for the people who drew them, they were an important form of relaying information.

Cuneiform

It was much later than cave paintings, some 5,000 – 6,000 years ago, that there is evidence of the earliest examples of writing. In the fertile crescent, around the valleys of the Tigris and Euphrates rivers, in what was later called Mesopotamia, the Sumerians developed a form of writing. This area is in present-day Iraq.

The Sumerians wrote using a wedge-shaped stick or reed, which was pressed into damp clay. The writing is called *cuneiform;* the word comes from the Latin word *cuneus,* meaning a wedge. Once it had dried in the hot sun, clay was very resistant, although it could be redamped and used again. A number of

battles and wars took place in this area, and when the attackers set fire to towns and cities this hardened the clay considerably and as a result many examples of cuneiform have survived, giving us a detailed picture of the sophisticated structure of Sumerian life.

A tablet of cuneiform, with the teacher's writing on the front (left), and the pupil's on the back (right).

They had schools with 'copybooks' showing two columns. On one side there is the teacher's writing as a model and on the other the child's writing, which has been copied – sometimes not very competently! They also had a money lending system with weekly and monthly accounts, and even a system of renting out land. Letters have survived, written on clay, and encased in a clay envelope, with the addressee's name inscribed on the outside. Some of the envelopes have yet to be opened! It is fascinating to think what messages these may contain.

Pictograms
It is not easy to 'write' or make marks quickly when pressing a stick into clay, and the first complicated drawings to represent objects became stylised so that a drawing was represented by just a few lines. These are called *pictograms*.

The drawing of a day (ud) and the sign to walk or stand (gin/gub) changed to less realistic shapes, but much easier and quicker to write. The pictograms, on the left, are dated at about 3,000 BC, the early cuneiform at about 2,400 BC and the much later form, now turned through 90°, on the right, at about 650 BC.

Ideograms

Gradually over the years the pictograms changed so that although the symbol for a sun originally represented just a sun, in time it came to represent a whole day, and even the idea of time itself. Pictures representing an idea not directly associated with the sign are called *ideograms.*

Ideograms are still used today, as they are a quick and easy means of communication which does not need language. The symbols for men and women's public lavatories are fairly standard throughout most of the world, similarly that for a public telephone and directional markings on roads. And, of course, the signs for numbers, which are ideograms, are the same throughout much of the western world. Even though we might not understand French, German or Portuguese we can understand distances on road signs because the signs for numbers are the same.

Ideograms are a clumsy way of conveying ideas, however, and the Sumerians eventually developed the idea that each symbol represented not just an object, but a sound as well. That same symbol for sun, representing the sun, day and time, came to represent the syllable *sun* (ud) used in combination to make other words.

This may not seem a remarkable step to us but it forms the original idea behind our alphabet today, that of symbols representing sounds. They did not get as far as one symbol representing one sound, instead the symbols stood for syllables

but this did reduce the number of cuneiform symbols from 2,000 to about 600.

Egyptians and hieroglyphics

The Egyptian writing system is thought to have started at about 3,000 BC and developed in a similar way to the Sumerian's. Using a brush and inkpots, the Egyptians developed a highly decorative style of writing called *hieroglyphics,* which was painted on to sheets of papyrus, and inscribed and painted on to stone and monuments.

Hieroglyphics from the papyrus of Hunefer. Also shown is Thoth, the god of knowledge, who was said to have taught the Egyptians hieroglyphics. He holds brushes and inkpots in his hand.

Hieroglyphics were deciphered relatively recently. Because they were found on temples and in tombs, they were thought to be holy writing. The ancient Greeks called the script 'sacred letters',

or 'the sacred carved (letters)' – *ta hieroglyphica*, from which hieroglyphics is clearly derived.

The Rosetta Stone

This stone, which provided the key to understanding hieroglyphics, was discovered in July 1799 by a group of French soldiers from Napoleon's army. They unearthed the stone whilst digging foundations for a fort. The stone is significant because it shows the same inscription written not only in *hieroglyphics*, but also in *demotic* (the script used for everyday writing in Egypt) and *Greek*. As Greek was a known language, it gave the clues for interpreting the demotic and hieroglyphics.

The Rosetta stone, showing hieroglyphics at the top, demotic writing in the middle and Greek at the bottom, from 196 BC.

(Reproduced by kind permission of the Trustees of the British Museum)

Papyrus

To make papyrus the outer skin of the reed is removed and strips of the inner pith laid in opposite directions and hammered together. Finally, the sheets of papyrus are smoothed with a stone.

Although pieces of papyrus in the British Museum, and indeed new sheets of papyrus made today, are light brown, there are early references to papyrus being white or much paler. The action of a pointed reed brush and good quality ink on white papyrus must have been very satisfying, and the joy of some scribes in making their mark can been seen in examples of their writing.

Red ink, made out of red earth oxide, water and gum, was used for names, titles, headings and the beginning of new paragraphs. Black ink, made from soot, water and gum, is still as solid and fresh today as it was when the letters were painted.

The hieroglyph for a scribe. On the left, in side view, is the narrow holder which is where the brushes were kept. This is joined by cords to the round bag holding the pigment, also in side view. This in turn is joined to the palette, which has two paint holes for black and red ink, and is shown from the top view.
(From the panel of Iry. Reproduced by kind permission of the Trustees of the British Museum)

Hieroglyphic 'letters' were not written one after the other, as with our words. Instead they were grouped in rectangles or squares, so that the shapes were pleasing to the eye. Sometimes the scribes changed symbols around for the best possible visual effect, without too much concern for the sense of the word. Even in those days scribes paid attention to the appearance of their work and how well it was presented and spaced.

*The hieroglyphics marked * have been changed round so that the shapes fit better. This often happened if there was a long tall sign next to a flat narrow one.*

The Phoenicians

It was the Phoenicians, living in what is now called Lebanon, who took the alphabet one stage further. They were a great trading nation, and travelled far and wide, even visiting Britain. It is likely that their alphabet was influenced by many different sources, and it seems that they adopted letters of other systems, simplifying them as they did so.

The most important aspect was that they applied one symbol to one sound, rather than one symbol to one *syllable*. Thus combinations of a limited number of symbols were able to make all the words. The symbols were simple and easy to make.

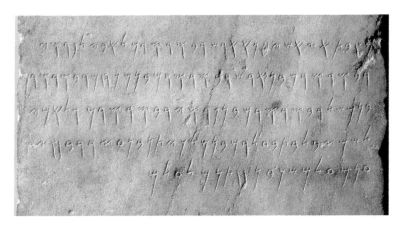

Phoenician letters inscribed on an obelisk, fourth century BC.
(Reproduced by kind permission of the Trustees of the British Museum)

Many of these old systems of writing only recorded the consonants. This may seem very confusing to us, but often words written like this can be recognised simply by their context. Try this out:

Mst wrds cn b rd qt sly b lkng t th cnsnnts. Vwls r nt lws ndd.

(Did you read this as: ' Most words can be read quite easily by looking at the consonants. Vowels are not always needed?' Problems only really occur if a word starts with a vowel.)

Arabic and Hebrew books and newspapers are still printed with no vowels.

The Greeks

In time, the Phoenician alphabet of twenty four letters was taken over by the neighbouring Greeks, who developed and adapted them for their own use.

Some letters had the same sound, and so were used directly in the Greek alphabet. Others were not related to the Greek language, and so the sound was changed, or the letter discarded. For example, the first letter of the Greek alphabet is alpha. This comes from the original pictograph in cuneiform for an ox – *alpu*, or *aleph* in Phonoecian. The 'sound' it represented is in fact difficult to write down. It is the 'glottal stop' between two vowels in the London and other accents: the sound of the ' in bo'l (bottle) and glo'l (glottal). The Greeks used the symbol for that for their letter **a**, which is rather a different sound.

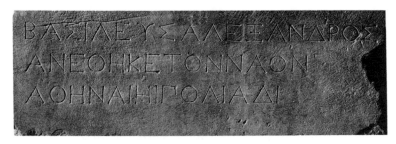

Beautifully sharp and crisp Greek letters cut into stone.

Writing direction

Initially, words were written from right to left, as in Arabic and Hebrew today. Exactly why the change was made from right to left to left to right is not certain. There are various theories: some think that it was the change in position from scribes writing on their laps on papyrus, as with the Egyptians, to at a table on skins as with the Greeks; others think that it was the movement of the hand, and that scribes needed to see what they were writing and not smudge their work. These theories would hold true if the change was made for *every* writing style. However, Arabic and Hebrew are still written from right to left and Chinese and Japanese vertically, in columns. None of these scribes seems to have problems about writing position or smudging their work, such that they need to change the direction of writing.

Boustrophedon

For a period of time, words were written not only from right to left, but then from left to right on the next line. This was called *boustrophedon*, (which is literally translated as 'ox turning') after the action of an ox ploughing a field.

THIS IS HOW A
SENTENCE LOOKS
IN BOUSTROPHEDON

Cursive writing

Greek letters on vases and carved as inscriptions were angular and precise. A more cursive style for everyday use was developed, which was quicker to write and easier to use.

Parchment

Throughout the ancient world many materials had been used for writing – stone, clay, wax, papyrus. It was the Greeks, at Pergamon, who are credited with the development of animal skins as a writing material.

Because it was made from a plant needing a specific climate and conditions to grow, the making of papyrus had been limited mainly to Egypt. This country controlled the supply of the writing material, regardless of demand. Animal skins had been used for thousands of years as a writing surface, but leather has only one side which can be used; parchment, however, has two. The animals used (sheep) could be raised in most places and thus a source of supply was assured.

The skins were, and still are, treated by being soaked in lime removing much of the hair and any remaining flesh, which are then scraped off. Strung out on frames, the skins are covered with powdered chalk to soak up the fat and then scraped with a curved bladed knife to remove any imperfections. The skin is removed from the frame and rolled until ready to use.

Scrolls and books

Sections of skin can be pasted together to make a scroll. In addition, pieces of the skin can be folded, put with other folded pieces, sewn together and made into a book, or *codex*. Information in book form is much more readily available than on a scroll; it is easy to turn pages and more information can be collected together in a book than on a scroll, where only one side could be used. In time books replaced scrolls.

With a scroll, only one side can be used as the reverse is constantly handled by the reader. It is not convenient to try to find pieces of text by having to roll the scroll backwards and forwards.

Both sides of the page can be used in books and thus more information can be stored in a smaller space. It is easier to look up references by simply turning the pages.

Roman letters

The alphabet which we use today comes from the Greek but was adapted by the Romans. They changed certain letters, as the Greeks had, for their own use. For example, they needed a sign for the letter **G**, the sound **g** (as in **g**ate). The letter **C** was already used for the **c** sound (as in **c**at), so the Romans added a stroke to **C** to make **G**.

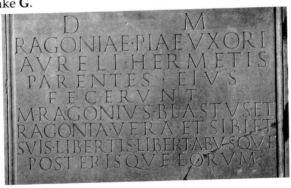

Roman letters carved into stone, showing classic proportions.
(Reproduced by kind permission of the Trustees of the British Museum)

The Trajan Column

As calligraphers, it is the beautiful Roman letters on carved inscriptions which are of special interest. These give us the proportions for capital letters which are still relevant today. Those on the *Trajan Column* in Rome are considered to be the nearest to perfection. The column was erected in 114 AD in Rome. It is thought that the letters were first written out with a straight-edged brush held at an angle of about 30°, which gave them their characteristic thicks and thins. Any study of the weight and proportions of these beautiful letters is well worthwhile

A student of Roman letters will notice that certain letters which we use today are missing. It was in the Middle Ages that **U** and **V** were identified as separate letters. Before that, the same symbol **V** was used in words for both sounds, only the sense distinguishing between them. Similarly, the letter **I** had been used for both **I** and **J** sounds; these letters were separately identified later in the seventeenth century. And in the eleventh century, the letter **W** came into existence.

Roman cursive

The capital letters as those on Trajan's Column were used for carved inscriptions on monuments. Alongside these formal letters were those developed by scribes for everyday use. A cursive hand, informal, quick and easy to write was written with a pointed stylus on a wax tablet. The tool and material resulted in a simplifying of strokes, and a straightening of curves – a style which eventually, when used with a reed pen or a brush on parchment, was almost unreadable!

Rustics

A more formal hand was used in books. A reed pen, with a broad edged nib, produced letters with thicks and thins. The pen was held with the nib at an angle of about 80° for the vertical strokes, and at a less steep angle for the other strokes. The resulting letters have narrow vertical strokes, and wide horizontal strokes. The letters are considerably compressed, and there is much pen manipulation. These letters were given the name of *Rustics* in the eighteenth century, probably because the view of people at that time was that this hand was not as sophisticated as inscriptional

lettering. Rustics have a great attraction, however, and were used in books as headings and section titles until the sixth century.

Rustic letters from a book in the Vatican Library. There is great style in these letters, which suit an important ecclesiastical work.

(Reproduced by kind permission of the Biblioteca Apostolica Vaticana)

Square capitals

These letters which were used in books, reflect the characteristics of monumental letters from inscriptions. The pen is held at the same angle, that is about 30°, but with some manipulation for the serifs and other strokes. Although it was first thought that they developed before Rustics, recent evidence suggests that Rustics are actually older. Square capitals were used in important manuscripts as they not only took up a lot of space, but were also time-consuming to write, and were thus highly regarded.

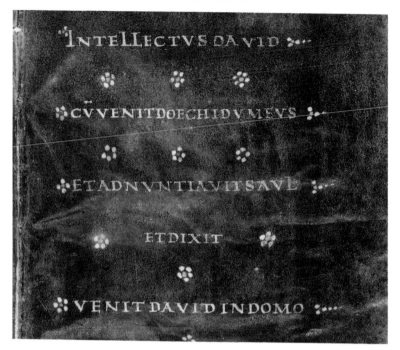

Square capitals written in gold on dyed vellum. For very precious manuscripts the vellum was dyed purple. The dye came from a marine snail (Murex brandaris) which yielded just one drop of dye.

(Reproduced by kind permission of the Bodleian Library, Oxford. MS Douce 59, folio 51R)

Runes

About the same time as these letters were used in manuscripts, that is from the second century to the Middle Ages and beyond, *Runes* were used to record information in northern and some parts of southern Europe. Runes were not really created for 'writing' but as a means of communication. They were designed to be *inscribed*, originally on wood, and then on other materials. There are many examples of Runes in Britain, mainly in the Scottish Islands, Ireland and the Isle of Man, where large memorial stones are decorated with Runes. Again the characteristic angular shape is due to the tools and the materials used. It is not easy to make curves quickly in wood with a sharp knife, far more practical to develop a system of symbols based on straight lines.

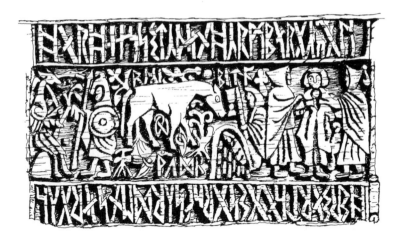

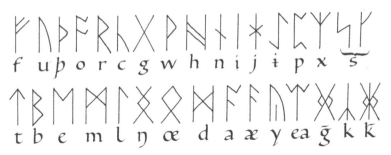

Anglo-Saxon runes on the Franks Casket, carved in whalebone. This alphabet is called 'futhork' after the names of the first six letters.

Uncials

Towards the end of the fourth century, changes took place in western Europe, which had an important effect on lettering. Significantly, Christianity was adopted as the official religion for the Roman Empire in 313 AD. This was also a period when the papyrus scroll died out in favour of the codex, or book, and magnificent books, predominantly religious, were produced on vellum with gold, silver and semi-precious minerals used as pigments, and with gold, silver and precious stones used on the binding.

This period is often referred to as *The Dark Ages,* but there was nothing dark about the illuminated paintings and the liveliness of the letterforms used by scribes at this time. Another style of writing was being used in these books, *Uncials.* It is thought that Uncials were so called because they were sometimes so large to be almost an inch (2·5 cm) high *(Uncial* derives from the twelfth part of a foot – an inch.)

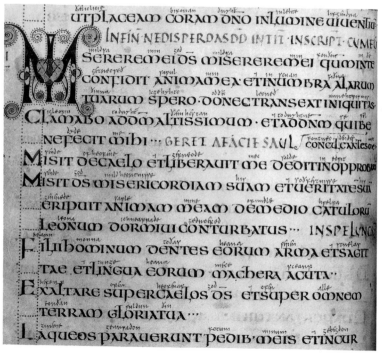

Uncials from the Vespasian Psalter. These tiny letters, written with a flat nib, have a gloss written in Anglo-Saxon Minuscules. The space needed for each hand is clearly in evidence.

(Reproduced by kind permission of the Trustees of the British Library)

This comfortable, round hand, with the pen held at a low angle, sometimes even completely flat, was used to copy out the Bible and Gospels in the highly developed scriptoria in western Europe. Ascenders and descenders, those parts of the letter which go above and below the line, were still tiny bud-like growths, as Uncials are essentially a capital letter alphabet.

234

Half-Uncials

Later, Half-Uncial letters developed but not, it is thought, directly from Uncials. They have ascenders and descenders clearly marked. Perhaps those in the Lindisfarne Gospels are the most beautiful, combined, as they are, with intricately decorated letters. The Book of Kells, too, contains a number of elaborately decorated initial letters which set off the Irish Half-Uncial hand. Interestingly enough, there is no gold in the Book of Kells, and very little in the Lindisfarne Gospels. It is the bright colours of the pigment, which still shine out from the vellum which suggests the use of gold. The pen nib was held at a flat angle for these letters. It is possible that the scribe cut a nib which was right oblique, so that writing was made a little more comfortable. The wedge-shaped serifs gave character to the hand, and were probably made with the corner of the pen for the letters **d g** and **t**.

Half-Uncial letters from the Lindisfarne Gospels. Note the prick marks which show where the scribe should start each line of writing.

Anglo-Saxon Minuscules

A more flowing hand, which was quicker to write, was developed by scribes in the eighth and ninth centuries, possibly from their own handwriting. The nib is held at a steep angle, and the letters carefully constructed. Even after Carolingian writing had been developed as the accepted style, Anglo-Saxon Minuscules continued to be used. An example of Anglo-Saxon Minuscules is shown on page 234 as a gloss to the Vespasian Psalter.

Carolingian letters

It was the Englishman Alcuin of York, trained by an Irish master, who helped to develop a new readable style of writing. The Emperor Charlemagne united much of Europe in the latter part of the eighth and the early part of the ninth century.

He was very interested in books, knowledge and learning. It concerned him that many of the manuscripts which had been copied were inaccurate, with mistakes which had not been corrected. Alcuin supervised the scriptorium at Tours and, with others, developed the *Carolingian* (named after Charlemagne) style of writing. It is a cursive, flowing script, easy to read and a joy to write. The nib is held at an angle of 20° – 30°, the letters written at a slope, with long ascenders and descenders.

Hierarchy of scripts

At about this time, a hierarchy of scripts was developed for using in manuscripts. Square Roman Capitals, based on inscriptional letters were used at the top for the most important headings. Then Uncials, followed by Rustics and finally Carolingian for the main text.

Palimpsests

In the great scriptoria established by Charlemagne, skins of vellum were regarded as a precious commodity. Writing out these vast books took an enormous number of skins, and none was wasted. Those which were not needed any more were scraped with a knife to be used again. These scraped and re-used skins, called *palimpsests*, must have contained many real treasures, which are completely lost to us now.

62

reprehendendae· Non·e·enim regnum di aesca etpotus· sed iustitia et pax et gau
dium· Et quia solent homines multum gaudere de carnalib; epulis· addidit in ipsu
sco· Aliter· lustificata·e· sapientia ab omnibus filiis suis· id·e· didispensatio atque
doctrina quae super bis resistat humilibus autem dat gratiam· lustefecit sea· si
delib; sui comprobata·e· ex quorum numero sunt et illi dequib; dictur· et omnis
populus audiens et publicani· iustificauerunt dm· Amer——

EXPLICIT LIBER SECVNDVS·

INCIPIT LIBER TERTIVS·

SANCTISSIMA MARIAE PAENITENTIS HISTORIA quae in
nostri in lucam caput·e·libri· et si oblaborem legentium minuendum·
A nouo inchoatur exordio· rerum tamen secundi libri neccura finem respicit
Nam quia superius· si ut experfona euangelistae· siue ex dni saluatoris utquib;
dam placuit dictum fuerat· et omnis populus audiens et publicani· iustifica
uerunt dm· baptizati baptismo iohannis· Quod si ad nodictum interpteris
Audiens iohannem populus intelligitur esse designatur· si ab euangelista
interpositum· Audiens ipsum dnm de iohannis magnitudine disputantem
restat intelligi· Pharisaei autem et legisperiti consilium dispraeuerunt
in semetipsos· Non baptizati ab eo· Pergit idem euangelista quae uerbis
proposuerat etiam factis astruere iustificatam uidelicet sapientiam ab
omnib; filiis suis· id·e· et ius eius· et postinui statiam paenitentib; decentissimo
comprobans exemplo liei sui eat SEDM luca a ? exullo apere·

LXIX R ozabat—— quidam de pharisaei ut manduca
ret cum illo; Et ingressus domum pharisaei discubuit, et ecce
mulier quae erat in ciuitate peccatrix· ut cog nouit quod accubuit
in domo pharisaei attulit alabastrum unguenti; & reliqua·

Alabastrum·e· genus marmoris candidi uariis coloribus; inter tincti
quod ad uasa ungentaria causare solent· eo quod optime seruare
incorrupta dicatur; Nascitur circa thebas aegyptias et damascum syrix
ceteris candidius· probatissimum uero in india· Quidam dicunt hanc
eandem Non esse mulierem quae in mente dominica passione· caput pedesq;
eius unguento perfudit· quia haec lacrimis lauerit et trine pede tersserit
et manifeste peccatrix appellatur· De illa autem nihil tale scriptum sit·

LX· nec poterit statim capte dni mereatrix dignafieri· Uerumquidiligentius
inuestigant· inuenuistic tandem mulierem mariam uidelicet magdalena
sororem lazari· sicut iohannes narrat· bis eodem functam fuisse obsequio·
Semel quidem hoc loco cum primo accedens cum humilitate et lacrimis·
remissionem meruit peccatorum· Nam et iohannes hoc quam uisnonut

*A manuscript showing the hierarchy of scripts, with Rustics, then
Uncials, followed by the main text in Carolingian. Initial letters are in
Versals. This manuscript was written at the scriptorium of Tours.*

(Reproduced by kind permission of the Bodleian Library, Oxford. MS Bodl. 218, folio 62R)

Making books

Book making had by this time become an artform. Skins of vellum (calfskin) or parchment (sheepskin) were cleaned and scraped smooth. Pages cut from the skins were folded in half and put together in folds of four or more. Using a carefully measured grid, the skins would then be pricked through with a sharp point to show the positions for writing the lines. These lines were scored with a smooth, hard point, which left a groove on one side and a slightly raised line on the other. Thus there was no need to rule lines on both sides of the sheet.

As there were no pencils, the design would be drawn with a lead point, or even indented very slightly with a silver or other metal point. Scribes, or probably illuminators, used very pale ink and a fine quill pen, possibly a crowquill, to go over the outline. Drawing instruments such as sets of compasses, rulers and set squares were used. Paint, made from ground earth tints, semiprecious metals and vegetable dyes, was mixed with gelatin, gum or glair (egg white) and water. The gelatin and glair provided the gum which kept the paint attached to the vellum. Ink was made from soot, water and gum, or more usually from oakgall nuts. These are the small nut-like growths made by gallwasps laying their eggs on the bark of oak trees. Acid was soaked out of the dried galls with water and the resulting colourless liquid then mixed with iron salt which made it turn black. Feathers, cured and hardened into quills were cut to size and used for writing and drawing.

When the book was finished, the book binder's skills sewed the sections together, and these were usually attached to wooden boards which were often decorated with precious and semiprecious jewels.

Round Hand

Gradually changes were made to the Carolingian style of writing and by the tenth century the Ramsey Psalter provided Edward Johnston with the model for his foundational, or *Round Hand*. Edward Johnston (1872–1944) was responsible for much of the revival of calligraphy in Britain and Europe. Calligraphy had slowly declined with the use of the printing press, and by Victorian times lettering had become little more than drawing. Work done initially by William Morris as part of the *Arts and*

Crafts Movement in the mid-1800s was continued by Johnston. They rediscovered the use of the broad nib pen, which automatically made the thicks and thins of letters. For this hand the pen is held at an angle of 30°, and many letters reflect the roundness of the letter **o.**

The Ramsey Psalter shows a strong, firm and confident Round Hand, and has been appreciated by scribes for the good model which Johnston recognised.

Gothic or Black Letter

Writing styles began to change and became narrower. Large numbers of sheep were needed to make the enormous Bibles of the early Middle Ages. Book writing and making was in greater demand and it became more like a business. Scribes and

illuminators advertised their skills and their wares. Books became smaller and were for personal use, either for meditation or simply to read. There were secular texts now as well as religious.

A compressed *Gothic* or *Black Letter* script developed in northern Europe; a style which is still used for the titles of some newspapers, and which remained popular in Germany until recently. This compressed script was far more economical in the use of skins for books. The pen is held at an angle of 45°, although a close study of this hand reveals that this angle was not constant. The lack of white space between and within the letters and their upright nature gives the hand its character.

Black Letter is a strong hand. This example is from a manuscript written in France about 1450 AD.

(From the author's collection)

Gothic Cursive or Bastarda

Gothic or Black Letter, formal and elegant, was used as a book hand. It is not particularly difficult, but it is time-consuming to write, with many pen-lifts. For everyday, writers developed a hand which included more curves and fewer lifts. This hand is called *Gothic Cursive*, or *Bastarda* (Bâtarde). It is also known as *secretary* or *charter script*, which indicates its use. This was developed into a book hand, which was used for some non-religious books. The pen nib is held at an angle of 30° – 35°, but this is changed to a much steeper angle for the long descenders of the letters **f** and **s**.

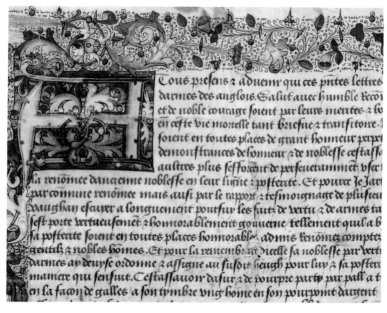

Gothic cursive script. This lively example is from a Grant of Arms written in 1492. Note the long descenders of the letters f and s.

(Reproduced by kind permission of the Trustees of the Victoria and Albert Museum)

Rotunda

In southern Europe a more rounded hand with Gothic influences was favoured. This is called *Rotunda*. It has a very impressive and

almost majestic feeling, and was often used in conjunction with decorated music manuscripts, written on large sheets of vellum for display purposes. The nib is held at an angle of 30°, and the pen is turned so that the tops and bottoms of letters are flat.

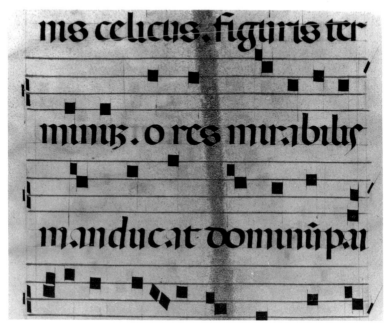

A large size Rotunda suits this music manuscript. The markings of the vellum are clearly shown. This is the hair side. The letters on the reverse, the flesh side, are much less lively and appear flatter.

(From the author's collection)

The Humanist style

The Renaissance beginning in the fifteenth century had an influence on lettering as well as many other areas of life and art.

Starting in Italy, there was a return to the classic proportions of the Roman letter. This was in a way easier for the Italians, as they were surrounded by so many good examples. There was a rejection of the complicated and contrived Gothic-style script, which included the Rotunda. Scribes returned to Carolingian and slightly later styles.

The resulting script, called *Humanist,* was adopted as a model for type design by the early printers. Although we do not use a two-storey **a** or a looped **g** in our handwriting, we are used to them because they frequently occur in the typefaces chosen for books and newspapers. These typefaces derive from those letterforms designed at this time based on the writing style.

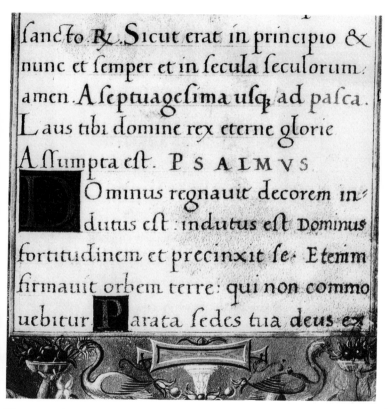

The central part of the page showing Humanist writing, which is not overpowered by the elaborate border.

Italic

A more casual style for handwriting was cursive *Italic.* As with previous cursive styles, it could also be used as a formal book

hand to great advantage. It was written by the copybook masters of the sixteenth century and was a hand favoured by the educated. It is interesting to note that this style of writing, based on an old script, is so popular for handwriting today.

C osi mi renda il cor pago et contento
 Di quel desio, ch'in lui piu caldo porto;
 Et colmi uoi dispeme et di conforto
 Lo ciel quetando il uostro alto lamento:
C om'io poco m'apprezzo, et talhor pento
 De le fatiche mie; chel dolce et scorto
 Vostro stil tanto honora: et sommi accorto,
 Ch'amor in uoi dritto giudicio ha spento.
B en son degni dhonor glinchiostri tutti,
 Onde scriuete; et per le genti nostre
 Ne ual grido maggior, che suon di squille.
P ero s'auen ch'in uoi percota et giostre
 L'empia fortuna; i sospir uostri e i lutti
 Si raro don di Clio scemi et tranquille.

A beautifully clear and well proportioned example of Italic by writing master Bembo. Upright capital letters at the beginning of each line work well with the sloping hand.

The printing press and typography

Fewer and fewer people were prepared to pay for a handwritten and illuminated book, when the printing press could produce books so cheaply and in such quantity. Johannes Gutenberg developed, with others, a system of moveable type for printing and produced his first dated work in 1454 AD, followed by his famous 'Forty-two line Bible'. This can be seen in the British Museum.

Calligraphers were still employed to design the letters and to add decorated initials to the text. The writing masters used the printing press to their advantage. They printed copy books and manuals on handwriting.

For these and other printed books, paper had long since replaced skins of vellum and parchment as a much cheaper alternative.

Copperplate

A new invention helped in the production of writing and copy books. Copperplate engraving, where a thin sheet of copper was engraved with a pointed burin, meant that the finest hairlines could be printed. Printing books in this way possibly influenced handwriting. A narrow pointed nib was developed which copied the hairlines and swellings of the engraver's burin. *Copperplate* writing became the accepted style, with very few pen lifts, and rather contrived joins to some of the letters.

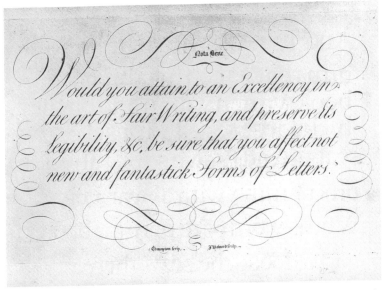

An example of Joseph Champion's work, used in George Bickham's publication, 'The Universal Penman'. The Copperplate here is elegant and restrained, with a message for all aspiring scribes!

(Reproduced by kind permission of the Trustees of the Victoria and Albert Museum)

It must have been a great boon for the ordinary schoolteacher, when, in the middle of the eighteenth century, penholders and metal nibs were manufactured for general use. Before this, one of their tasks was to cut and sharpen all the quills used by their pupils.

The twentieth century

And so to the modern day. We owe a great deal to the good ground laid by William Morris, who promoted a return to the old skills and crafts, which had almost been forgotten. Edward Johnston, too, revived the study of old manuscripts, and developed the use of the broad-edge nib. He also experimented with inks and pigments, and it was his studies, together with those of his pupils, which revealed the techniques that the illuminators had used in medieval times. They were aware of good letterforms, promoted a study of historical scripts and yet encouraged this to be a basis for a personal style for calligraphy, rather than a slavish copy of old manuscripts.

And I saw in the right hand of him that sat on the throne a book written within and on the back, close sealed with seven seals. And I saw a strong angel proclaiming with a great voice, Who is worthy to open the book, and to loose the seals thereof ? And no one in the heaven, or on

Edward Johnston's calligraphy has such verve and energy that it almost leaps off the page.

(Reproduced by kind permission of the Trustees of the Victoria and Albert Museum)

Further Reading

The following books are suggested for more detailed study of the history of writing.

Avrin, Leila, *Scribes, Scripts and Books*, American Library Association and The British Library, Chicago and London, 1991

Backhouse, Janet, *The Lindisfarne Gospels*, Phaidon and The British Library, Oxford, 1981

Catich, Father Edward, *The Trajan Inscription in Rome*, Catfish Press, Iowa, 1961

Father Edward, *The Origin of the Serif*, Catfish Press, Iowa, 1968

de Hamel, Christopher, *A History of Illuminated Manuscripts*, Phaidon, Oxford, 1986

Diringer, David, *Writing*, Hutchinson, New York, 1962

Diringer, David, *The Alphabet, A Key to the History of Mankind*, 2 vol, Hutchinson, New York and London, 1968

Evetts, L.C., *Roman Lettering*, Pitman and Sons, London, 1938

Fairbank, Alfred, *A Book of Scripts*, Penguin, Middlesex, 1948

Gaur, Albertine, *A History of Writing*, The British Museum, London, 1984

Gray, Nicolette, *A History of Lettering*, Phaidon, Oxford, 1986

Hooker, J.T., *Reading The Past: Ancient Writing from Cuneiform to the Alphabet*, The British Museum, London, 1990

Jackson, Donald, *The Story of Writing*, Cassell, London, 1981

Knight, Stan, *Historical Scripts*, A & C Black, London, 1984

Ogg, Oscar, *Three Classics of Italian Calligraphy*, Dover Publications, New York, 1953

Page, R.I., *Reading the Past: Runes*, The British Museum, London, 1987

Wardrop, James, *The Script of Humanism*, Oxford University Press, Oxford, 1963

Whalley, Joyce Irene, *The Art of Calligraphy, Western Europe and America*, Bloomsbury Books, London, 1980

Woodcock, John, *A Book of Formal Scripts*, A & C Black, London, 1992

Index

*Where there is more than one page
reference the main entry for items is
shown in **bold** type.*